CW00820966

# CLAPHAM
## THROUGH TIME
Alyson Wilson
& Claire Fry

AMBERLEY

# About The Authors

Alyson Wilson has lived in Clapham for nearly fifty years and has always taken a keen interest in local history. Alongside her career as an art historian and researcher, she has written and edited several books about Clapham.

She is a member of the Clapham Society's Local History Sub-committee, and gratefully acknowledges the opportunity to draw on the extensive research and images provided by other member of the group and past historians of the area.

Claire Fry is a graphic designer who has lived in Clapham for over thirty years. She has a special love of the Common, where she walks her dog. She has a strong interest in the changes that have taken place in Clapham over the years, and records these regularly with her camera.

First published 2015

Amberley Publishing
The Hill, Stroud
Gloucestershire, GL5 4EP

www.amberley-books.com

Copyright © Alyson Wilson and Claire Fry, 2015

The right of Alyson Wilson and Claire Fry
to be identified as the Author of this work
has been asserted in accordance with the
Copyrights, Designs and Patents Act 1988.

ISBN 978 1 4456 4804 0 (print)
ISBN 978 1 4456 4805 7 (ebook)

All rights reserved. No part of this book may be reprinted or reproduced or utilised in any form or by any electronic, mechanical or other means, now known or hereafter invented, including photocopying and recording, or in any information storage or retrieval system, without the permission in writing from the Publishers.

British Library Cataloguing in Publication Data.
A catalogue record for this book is available from the British Library.

Typesetting by Amberley Publishing.
Printed in the UK.

# Introduction

Once a Surrey village, by the end of the nineteenth century Clapham was a prosperous inner London suburb. Some eighteenth-century mansions remained, and large Victorian villas were set in leafy avenues, but most streets consisted of terraced houses built in the previous three or four decades. Schools, churches, shops and the park-like Common provided for the citizens' needs.

In the next century much was to change, more especially in the last fifty years or less. By the mid-twentieth century Clapham was unfashionable and suffering from war damage. Several bomb sites remained undeveloped until relatively recently, when land values in the area had risen sufficiently to make the sites of interest to developers. Factories employing local people have gone and employment is now mainly in the service industries. We have been fortunate to retain a few independent shops and cafés.

Most striking is the demand for residential accommodation in the last few years. But although sites have been densely filled, Clapham has escaped the high-rise mania which has gripped areas closer to the river. Most demolished buildings have been replaced by ones of similar height, so although we may not like the new buildings the rhythm and overall pattern have been preserved. There are some bland new buildings and conversions, but also successful ones.

Many changes to shopping streets are superficial, simply reflecting changes in style and design at ground level. Look upwards and you may find the original building is intact, and often in better condition than in the past.

As interesting as the buildings are the changes in the appearance of people and the clothes they wear; the vehicles from horse trams to Boris buses, bicycles, prams and buggies; the empty streets compared with the parked cars, yellow 'Keep Clear' boxes and no parking lines, blue cycle routes, red routes, traffic lights and crossings – the general clutter of the twenty-first century.

The quiet streets of Edwardian Clapham may look appealing but mid-twentieth-century Clapham was quite drab and dull. Gentrification has meant that owner-occupiers have restored houses, formerly in multiple occupancy, as single-family homes, and maintained them well. Life has changed hugely, and interesting as it is to look back at the past we should also welcome many of the changes.

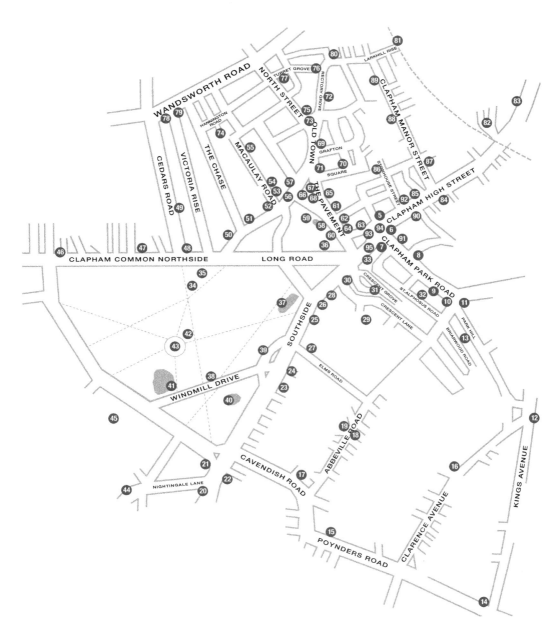

The number in each dot indicates the page on which the pictures of that location can be found.

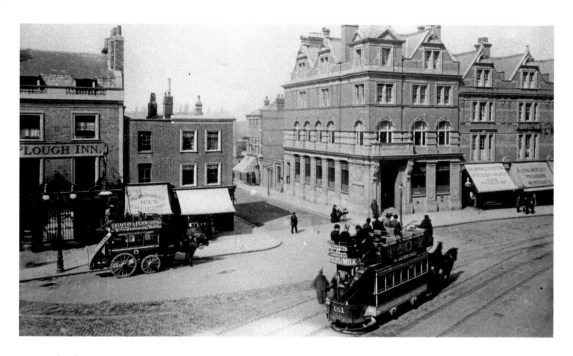

## Clapham Cross

The top picture was taken in about 1900 when the building on the corner of Venn Street (now Barclays Bank) had been recently completed. On the opposite corner was Jones tobacconist shop to which the tall classical pedimented façade, faced in semi-glossy tiles was added in 1919 as the entrance to a cinema to be called The Coliseum, which was never completed. The Plough on the left, originally an eighteenth century coaching inn, was refronted in Tudor style in 1928, and has changed its name several times since. The bottom picture shows the colourful tents of the Venn Street Saturday market.

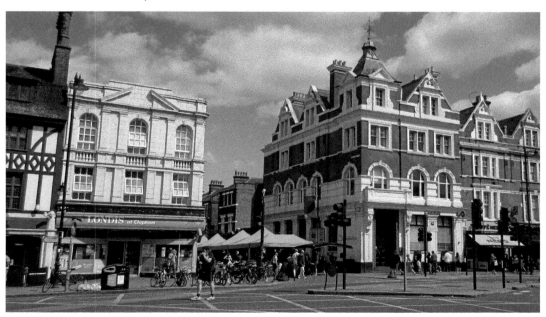

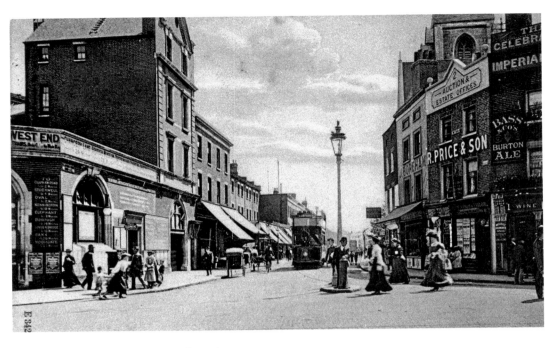

## Clapham Common Underground Station

The Underground came to Clapham in 1900 when the City and South London line was extended from Stockwell. The line terminated here with the station entrance on the corner of Clapham High Street and Clapham Park Road as shown in the top picture. When the line was extended to Morden in 1926 the new station was built in its present location. One of ventilation shafts for the Second World War deep shelter is now on the site and the top can just be seen behind the hoarding in the bottom picture.

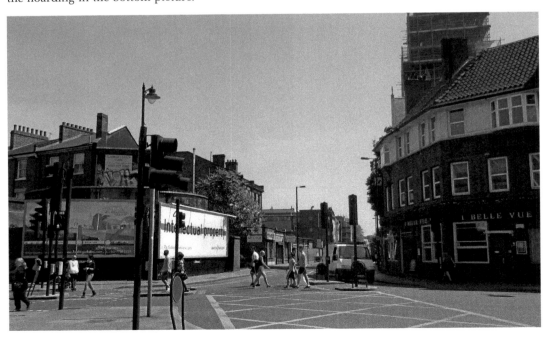

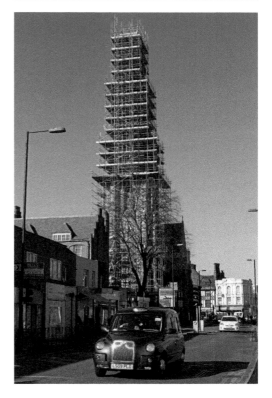

15160   R. C. CHURCH.                    CLAPHAM.

**St Mary's Roman Catholic Church**
St Mary's Church (1849–51), by William
Wardell a pupil of A. W. N. Pugin, was one of
the first new churches constructed in England
after the Catholic Emancipation Act. It was
built on the grounds of a large mansion which
was demolished in 1890 for an extension to
the church and the Redemptorist Monastery
by J. F. Bentley, architect of Westminster
Cathedral, who lived locally. The castellated
wall of the monastery can be seen on the left
of the church in both pictures. In 2015 the
church is undergoing extensive repairs to the
stonework of the spire.

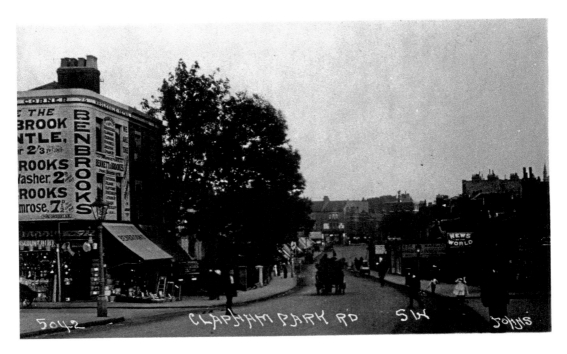

### Clapham Park Road Looking South

In the 1970s Lambeth Council's Carfax Place Estate, on the right of the bottom picture, replaced the artisan dwellings of Carfax Square, a former Roman Catholic School in Holwood Place and workshops in Acre Square. The low-rise estate includes flats, town houses and sheltered housing. On the left Benbrook's Household Stores went through several reincarnations as a pub, restaurant and bar, before being replaced in 2015 by a block of nine flats with a retail unit on the ground floor.

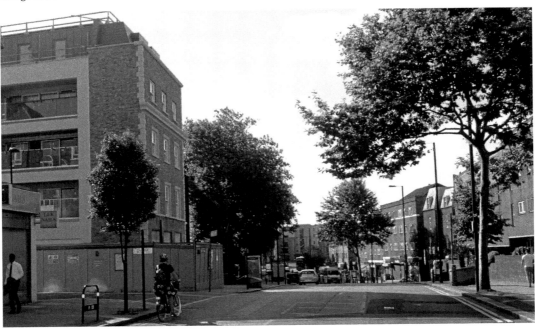

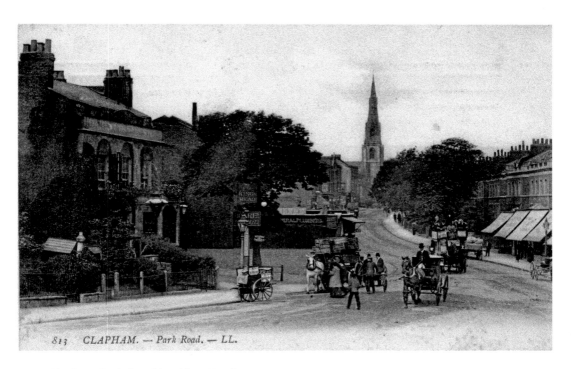

*813 CLAPHAM. — Park Road. — LL.*

### Clapham Park Road Looking North

Most of this street was rebuilt in the late twentieth century. The shops and houses on the right of the top picture were replaced by the Bowland Road Estate from 1978 onwards, and those on the other side of the road by the Carfax Place Estate. In the left foreground the King's Head pub is the one survival in the street, though it has been altered considerably over the years, and is now called The King & Co.

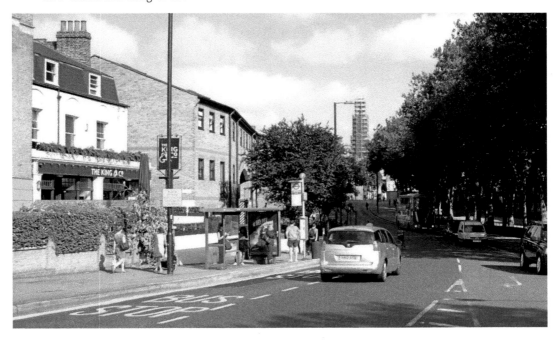

9

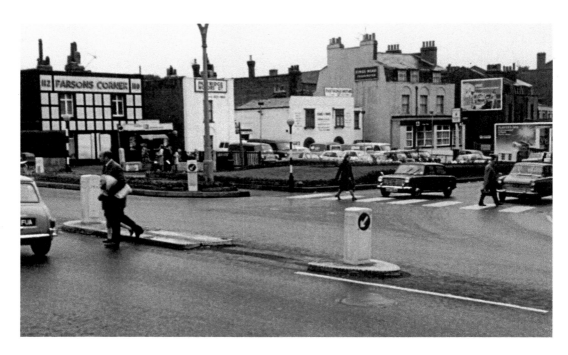

## Parsons Corner

This junction where Clapham Park Road takes a sharp right-angled turn is named after the newsagent who had a shop on the other side of the road. This was destroyed in the Second World War, following which he set up and ran for many years a kiosk on the forecourt of Nos 110 to 112. The building still proudly bears the name 'Parsons Corner'. Adjoining buildings were demolished in the late 1990s and the site has been redeveloped as flats. The former King's Head pub, now called The King & Co. can just be seen dwarfed by the new block.

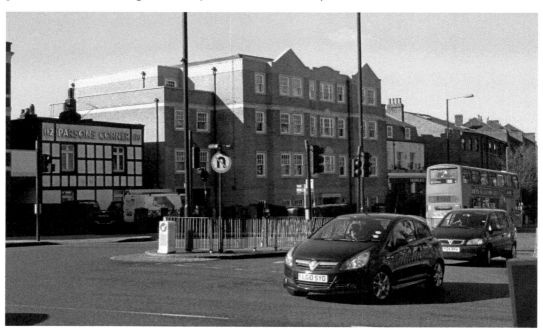

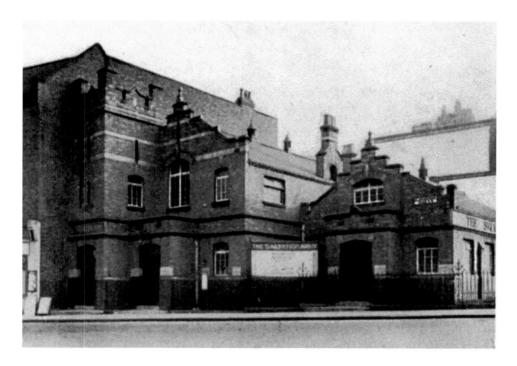

## Salvation Army Citadel

A row of small shops on the corner of Park Hill and Clapham Park Road was replaced by the Salvation Army Citadel in 1908. This was demolished following serious bomb damage in the Second World War, and rebuilt soon after the war. A few years later the building became Christ Embassy Church. Following the closure of the church the site was redeveloped, in conjunction with adjoining sites, as flats with a dental practice on the ground floor.

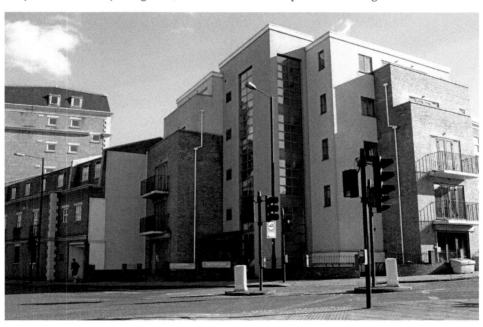

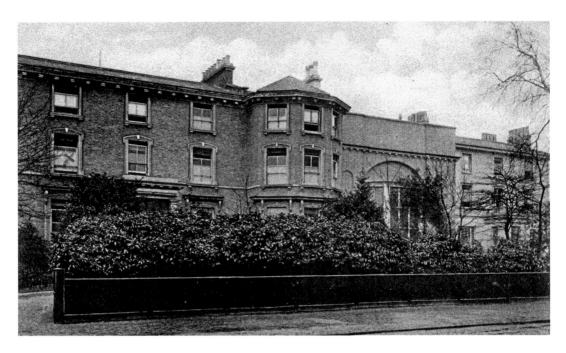

## Queenswood School, Kings Avenue

In the 1870s two large detached houses in Kings Avenue were converted into a school for the daughters of Wesleyan Ministers. This closed in 1893, reopening the following year as Queenswood School for Girls. Various alterations and additions were made, including a chapel (seen on the right of the top picture). The school had a gym, four tennis courts and a ten-acre sports field. In 1925 Queenwood School moved out of London to Hatfield, where it still is, and the buildings were converted to flats. There have been so many external alterations to give the flats, now Queenwood Court, a more unified appearance that it is difficult to determine exactly what is original.

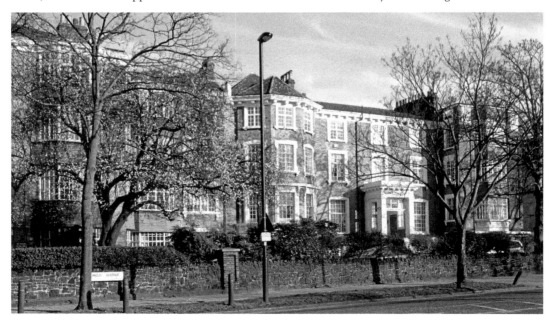

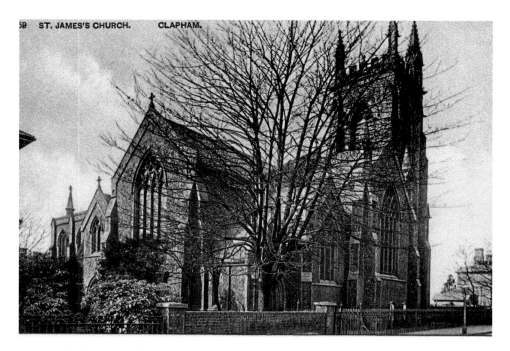

St James's Church, Park Hill

St James's Church was built in 1829, but by 1870 it was too small for the congregation and in a bad state of repair, so it was restored and extended to provide an extra 500 seats. In September 1940 the church was totally destroyed by German bombing, but 300 people who were sheltering in the crypt all emerged unscathed. After the war a new church was designed by N. F. Cachemaille-Day, one of the leading church architects of the twentieth century, noted for his austere use of brick and reinforced concrete. The church was consecrated by the Bishop of Southwark in 1958.

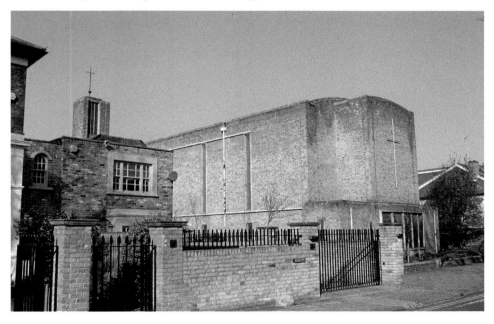

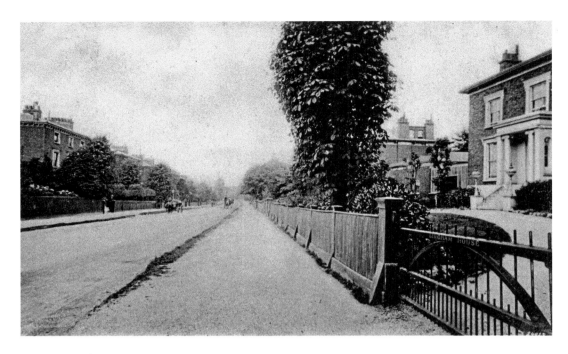

## Queens Road

Queens Road now forms part of Poynders Road, so-named after Thomas Poynder (1750–1830) the original owner of the farmland through which the road passed. The detached villas which once lined the road as part of Thomas Cubitt's development of Clapham Park, became derelict after the Second World War and were replaced by the western extension of Clapham Park Estate. Queens Road is now part of the busy South Circular Road, and a far cry from the leafy Edwardian lane shown here.

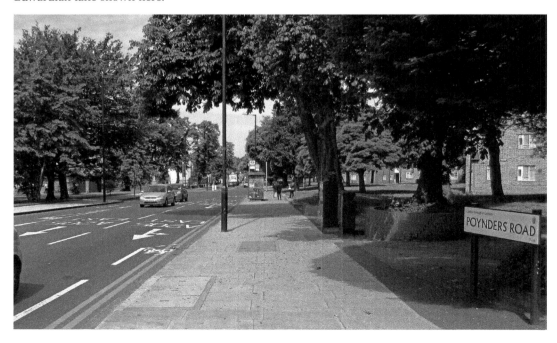

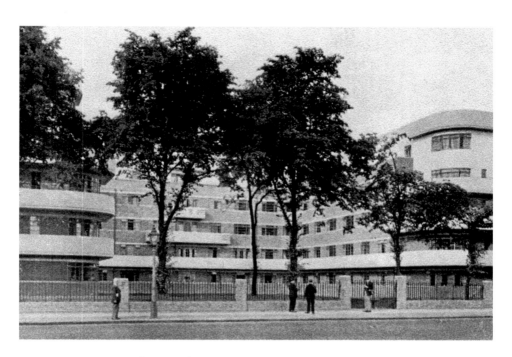

### Eastman House, Poynders Road

Part of the Oaklands Estate this block of Moderne-style flats was built in 1935–36 by the London County Council Architects' Department under the direction of E. P. Wheeler. The two top floors of the five-storey block were designed as maisonettes. Wide steel-framed windows gave maximum light, and there was a rear courtyard, children's playground, a clubhouse, bicycle racks and invalid chair storage – all novelties in social housing at the time.

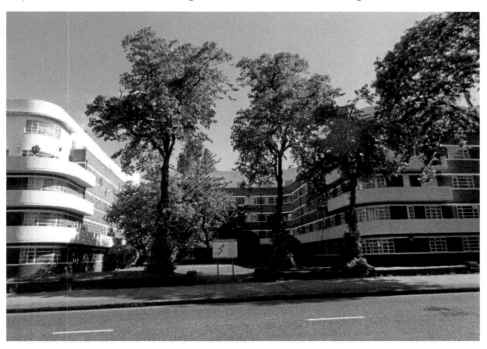

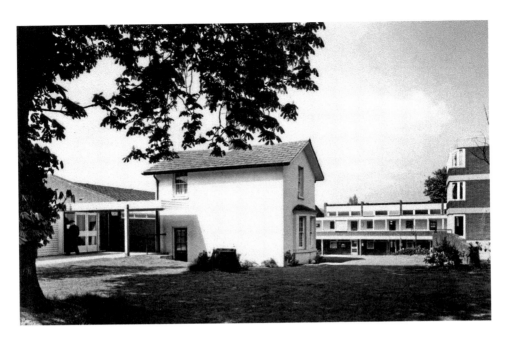

### Clifton, Clarence Avenue

The last vestige of Thomas Cubitt's own residence in Clapham Park was this tiny house called Clifton built in his grounds in 1830 as the home of his estate manager, John Clifton. From the 1960s it was the Warden's house for a home for the elderly and adjoining low-rise sheltered housing built by Lambeth Council. There were individual studio flats, communal dining and recreation facilities, and a landscaped outdoor space. The home was also called Clifton after Cubitt's manager. The small historic house and all the other buildings were demolished in 2010 and the entire site densely covered with flats in 2011. This includes an extra care scheme, provided by the Metropolitan Housing Trust, with 50 one- and two-bedroom flats on five floors.

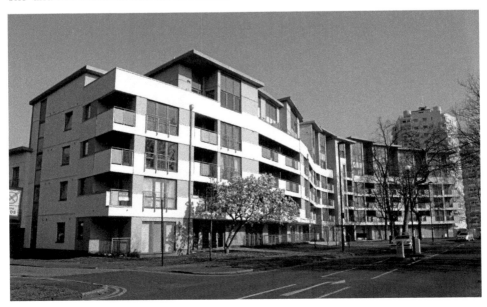

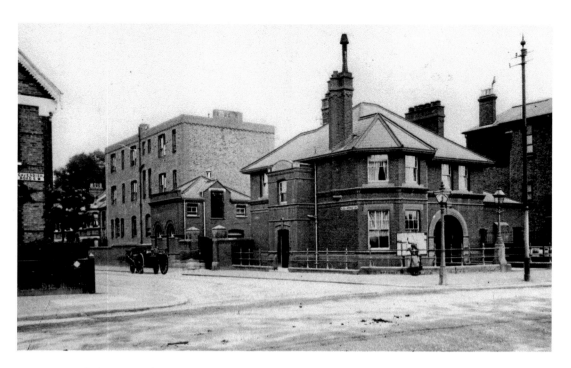

### Cavendish Road Police Station

This was originally Balham Police Station built in 1891, and the Section House behind was added in 1903. Section Houses, which were built to accommodate police officers, have now mostly been sold off. Cavendish Road Police Station, unusually, still retains its distinctive blue Metropolitan Police lantern. The station was closed from 1974 to 1984, and again threatened with closure in 1999, but so far it has survived.

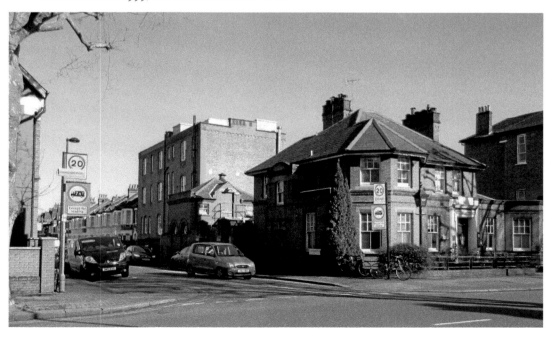

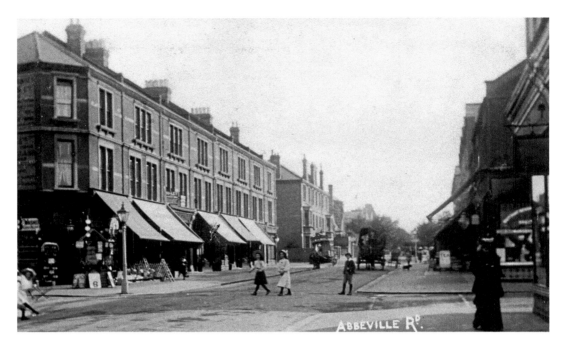

## Abbeville Road

This part of Abbeville Road between Narbonne Avenue and Hambalt Road was developed in the 1890s as a local shopping centre, providing for the needs of the residents in the new streets around it. Shown above c. 1918, it still retains its shops today, though cafés, restaurants and estate agents have replaced many food and general stores. The lower picture was taken at the annual summer street fair, when shopkeepers join craftspeople and local organisations with stands on the pavement.

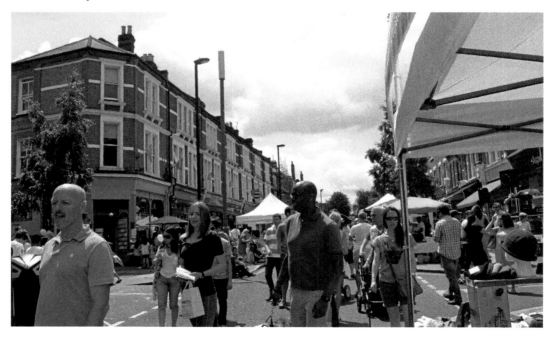

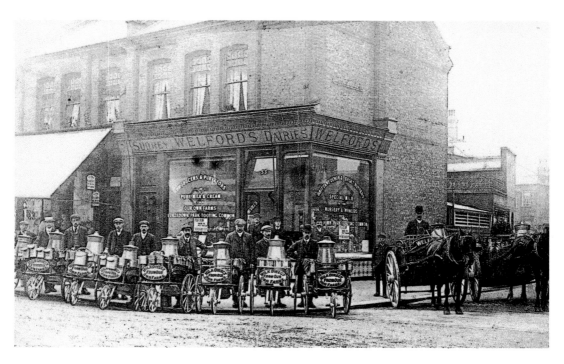

## Abbeville Road Dairy

This picture of Welford's Surrey Dairies Limited at No. 53 Abbeville Road in around 1900 shows the delivery carts, each with a milk churn and different sized measuring jugs on the front, lined up ready for the morning delivery. Customers would come out with their own jugs to be filled with milk measured from the churn. The upper part of the building remains exactly as it was then. There was a dairy on the site until the 1930s.

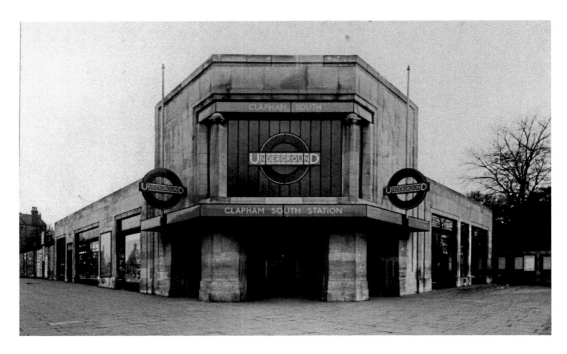

## Clapham South Station

This was the first new station built when the Northern Line was extended from Clapham Common to Morden in 1926. The architect, Charles Holden, was responsible for many London underground stations, and most notably for London Transport's Westminster headquarters, No. 55 Broadway. The station was originally to be called Nightingale Lane. Although built as single storey with adjoining shops, it was always intended to have flats above but these did not materialise until 1937 when Westbury Court was built. Though not as grand as some local blocks Westbury Court had a restaurant, a staff of eight, a night porter and a gardener.

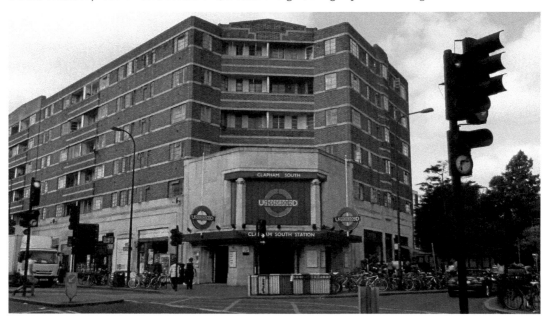

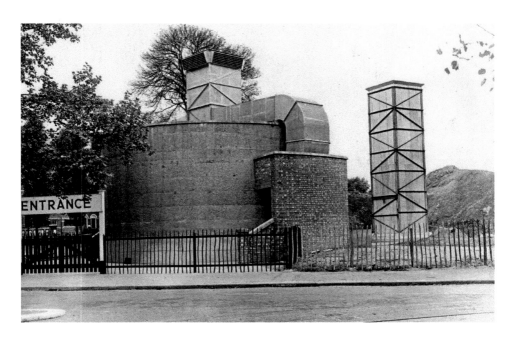

## Clapham South Deep Shelter

In response to the London Blitz in 1940 the government started building air raid shelters beneath some existing Northern Line underground stations. The intention that these would later be converted to an express railway line was never realised. Ventilation shafts like these survive near the three Clapham underground stations. On the extreme right of the top picture the pile of spoil from the digging can be seen. The Clapham South shelter housed families made homeless by the Second World War bombing, immigrants from Jamaica on the *Empire Windrush* in 1948 and visitors to the Festival of Britain in 1951. After many years as archive storage, in 2015 Transport for London put forward a proposal to open the shelter to visitors, with a display of Second World War memorabilia and a café at ground level.

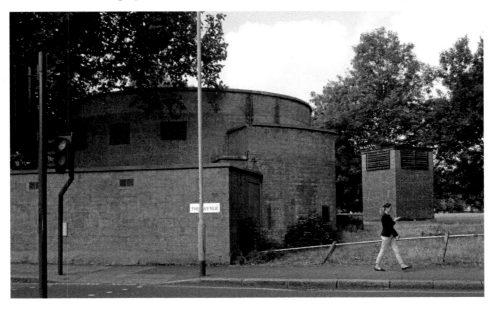

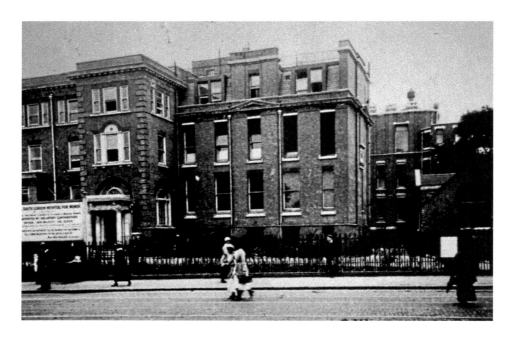

## South London Hospital

The hospital was opened in 1916 by Dr Maud Chadburn, a pioneering surgeon who was determined to open a women's hospital in South London in the face of strong opposition from the male medical establishment. An extension by the architect Sir Edwin Cooper opened in 1935, replacing part of the original hospital. Despite a spirited campaign to preserve it, the hospital closed in 1984. Many years of dispute and opposition to planning applications followed before Tesco eventually secured permission to build a supermarket, on condition the 1935 façade was retained. This can be seen on the extreme left of the bottom picture. The archway and the block above it were added by Tesco in the spirit of the Cooper design; they lead to a car park and block of flats behind, built on the former grounds of the hospital.

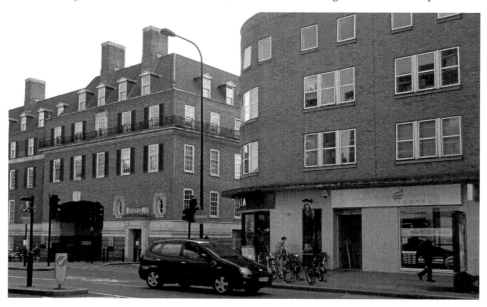

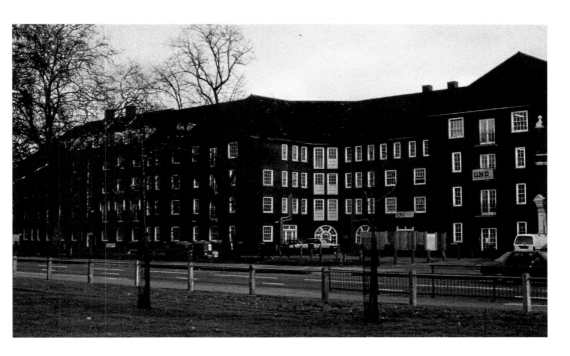

## Montrose Court Hotel

The original three Victorian villas on this site were linked to form the Montrose Court Hotel, which was rebuilt in the 1930s as shown above. The hotel closed in 1949 and the building was converted for use as a hall of residence for students at London University's Kings College. In 1997 this was demolished and the present block of flats built, with projecting wings echoing the former building. The Clapham Palais de Danse was behind the hotel, and the names Charleston House and Wakeford Close reflect a popular dance of the time and the hotel's architect.

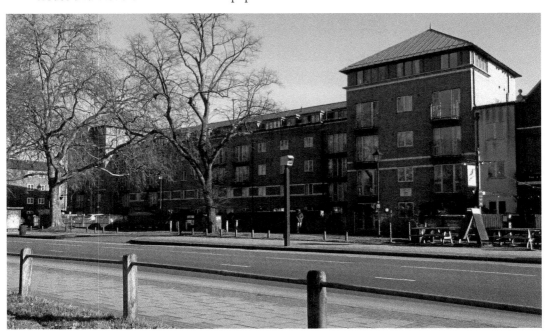

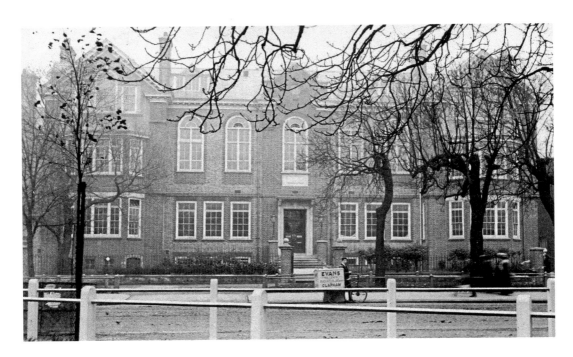

## Clapham High School for Girls

The school was built in 1903 and closed in 1938, due to falling rolls. The following year the building was requisitioned for army use during the Second World War. Former pupils included Mair and Megan Lloyd-George, who introduced Frances Stevenson to their father, Prime Minister David Lloyd-George, whose secretary, mistress and second wife she became. In 1949 the school reopened as St Gerard's Roman Catholic Boys' School, which was demolished *c.* 1980 when the site including the extensive grounds, was redeveloped as small houses and flats with the present name, St Gerard's Close, recalling the former school.

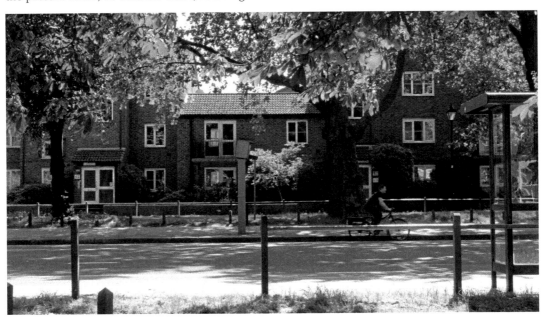

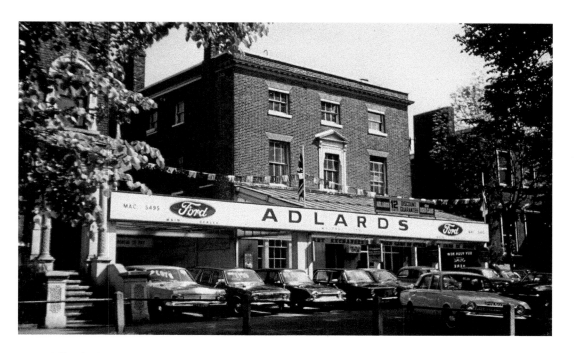

## Adlards Garage

This handsome late eighteenth-century house with Venetian windows on either side of the front door was once the home of the architect Lewis Vulliamy (1791–1871). From 1924 it was a garage and motor car workshop with various additions behind and in front. Over the years local residents became increasingly concerned about the inappropriate frontage and many parked cars. The garage closed in the 1980s, the outbuildings were demolished, a wing added to link with No. 52 and the house converted to office use. The gated Shaftesbury Mews was later built in the grounds. The house has now been restored as a single-family residence.

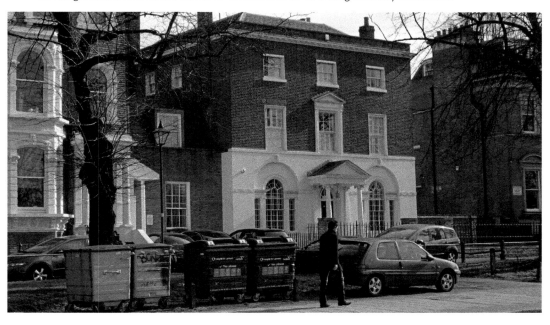

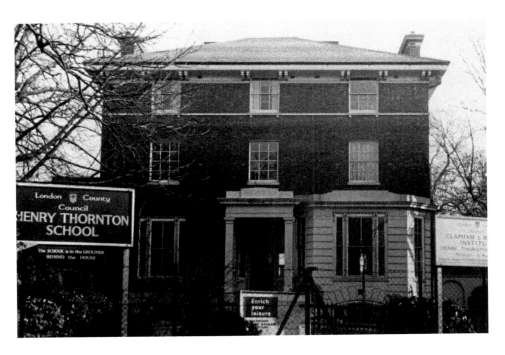

## Henry Thornton School

In 1929 Battersea County Grammar School moved to Clapham to new buildings in the grounds of No. 44 South Side, and was renamed to celebrate the local philanthropist, Henry Thornton. The original house, shown above *c.* 1930, housed the school library, dining room and school-keeper's quarters. In the late 1960s, the house was demolished and the school was largely rebuilt when it became a comprehensive school. This closed in 1987 and Lambeth College (a Further Education College) opened in the refurbished buildings in 1993. The College was further extended, as shown below, in 2012.

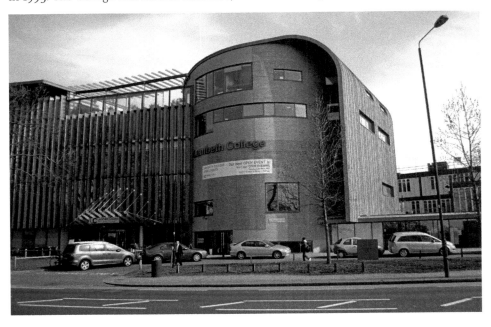

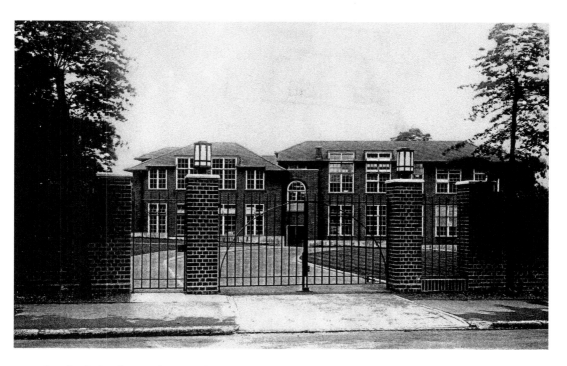

### Lambeth Academy, Elms Road

The top picture shows the new building of 1929 for Henry Thornton School, the frontage of which was on Clapham Common South Side. This was the main classroom area, and pupils' access. When the school closed and Lambeth College opened in the buildings on South Side this became Henry Thornton Adult Education Centre. The centre was demolished in 2003 and replaced by Lambeth Academy, which was opened by Elizabeth II in 2004.

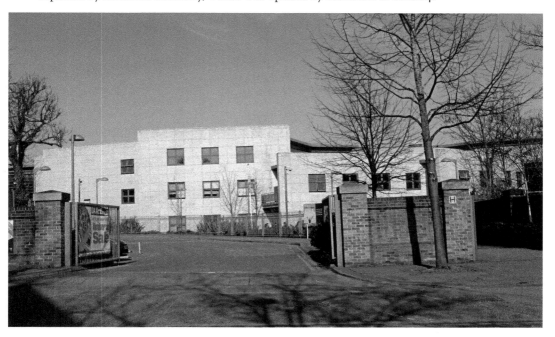

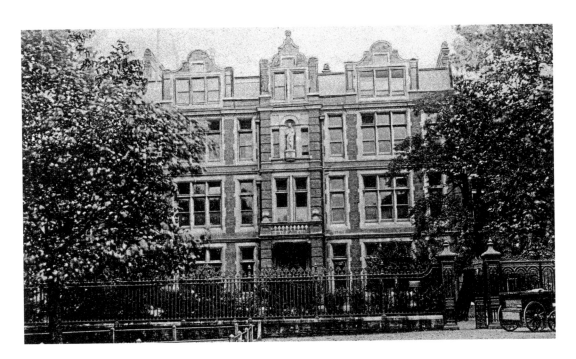

## Notre Dame School

In 1851 three adjoining eighteenth-century mansions and their grounds were purchased by the Belgian sisters of Notre Dame who had recently arrived in Clapham. The houses were linked with new buildings (shown above) to form a convent school with extensive playing fields, and a lake behind. The school was evacuated during the Second World War and the buildings occupied by the Free French. In 1949 the site was cleared and Notre Dame Estate built in several phases by Wandsworth Council. The eight-storey blocks facing the common won a Ministry of Housing award in 1952.

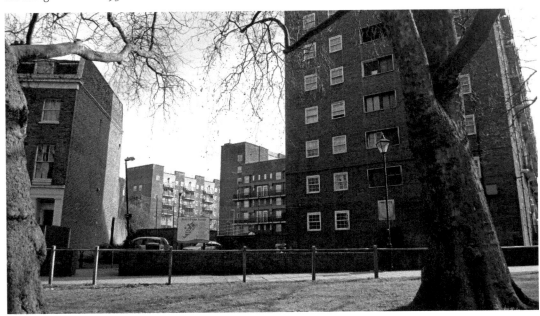

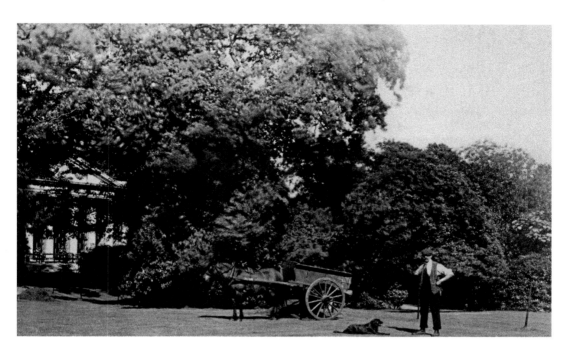

### The Orangery

Robert Thornton (1757–1826), the black sheep of the philanthropic Thornton family, lived in one of the mansions on South Side, which later became part of Notre Dame Convent. It was set in extensive grounds, with a lake, and several garden buildings including this 'orangery' or summerhouse, where he entertained guests. The building survived in the school grounds, and is now surrounded by the Notre Dame Estate. Various schemes over the years to bring it back into use as part of a community centre have, as yet, not been successful and despite some maintenance it looks rather sad today.

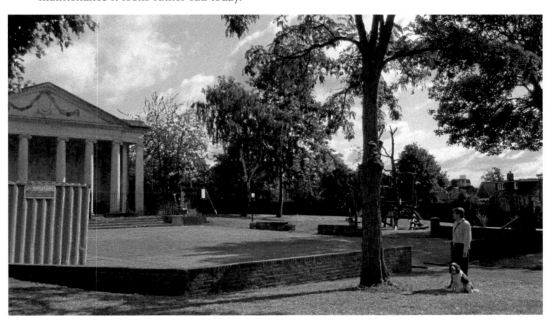

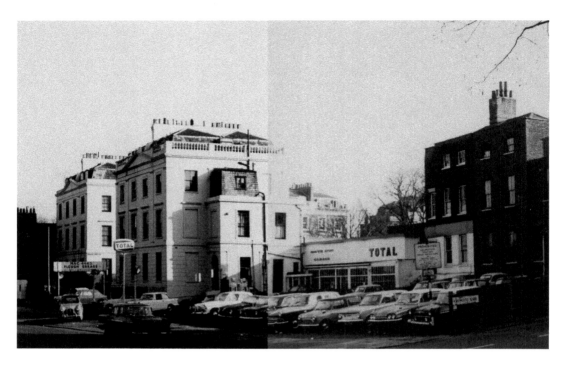

## Nos 30–31 Clapham Common South Side

There were once two eighteenth-century houses on this corner of Crescent Lane, one of which was the home of William Hibbert whose two daughters, in 1859, founded the Hibbert Almshouses in Wandsworth Road in his memory. By the 1960s there was a petrol station on the former front garden where yet another of Clapham's many second-hand car dealers displayed their cars. When the garage closed the site was derelict for many years, until it was finally cleared, the houses demolished and the present block of flats built in the 1980s.

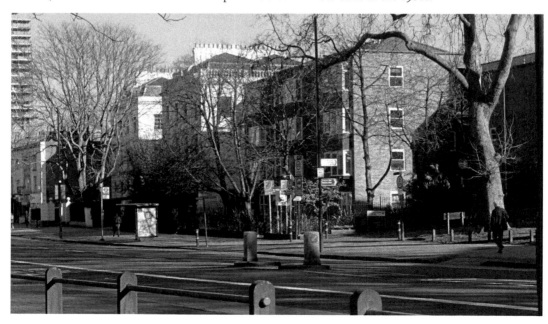

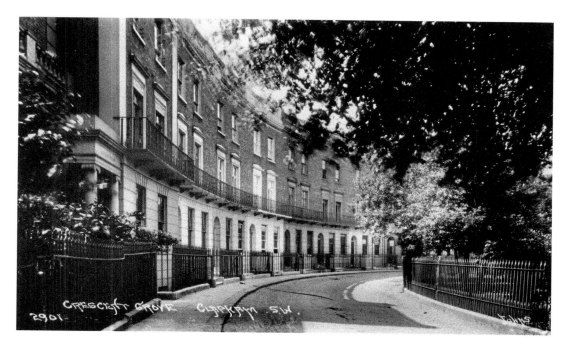

## Crescent Grove

In 1824 Francis Child laid out this private estate as a family investment. His own large house (now demolished) stood at one end with a crescent of terraced houses along one side, semi-detached houses linked by coach houses on the other side, a central garden enclosed by railings (removed during the Second World War) and two pairs of imposing houses at the entrance from South Side. Crescent Grove is still a private estate and residents are responsible for the upkeep of the road and gardens. By the mid-twentieth century most houses were in multiple occupancy and the estate neglected, but Crescent Grove is now well-maintained and has largely retained its original character.

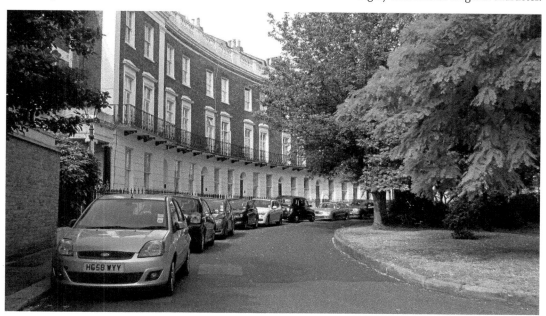

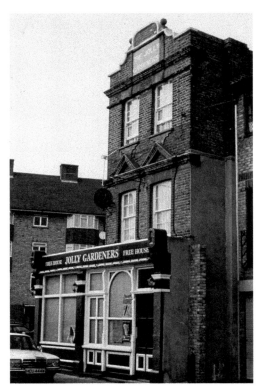

Jolly Gardeners, St Alphonsus Road
Built in around 1890 this house was
converted to a pub in the 1920s. The pub
and a few pairs of nineteenth-century
cottages opposite were the only remains of
the earlier street when the rest was rebuilt
in the 1970s and 1980s. For some reason
the Jolly Gardeners survived incongruously
amongst its new neighbours until 2014
when it was finally demolished and replaced
with a block comprising five flats with
ground floor and basement retail units.
Since there has been no interest in the retail
space, there is currently an application to
change it to residential.

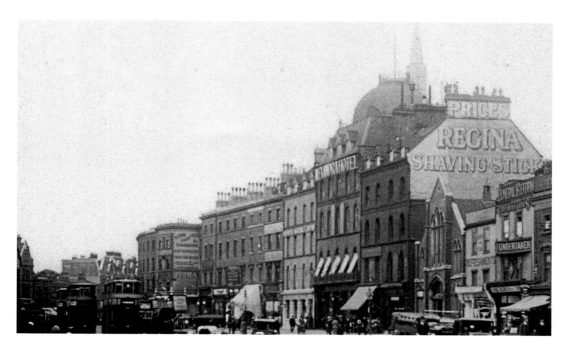

## The Alexandra

Slightly to the right of centre in the top picture can be seen the Gothic windows and gable of the former Baptist chapel. When the chapel moved in 1886 this became a post office and was re-fronted in neo-Georgian style in the 1930s. It has been altered several times since for different restaurants, and is now Honky Tonk, but traces of former styles survive. Next door the Alexandra Hotel, by the local architect Edward I'Anson, originally included flanking buildings on each side, but these were later sold off. The painted advertisement high on the wall is still just visible.

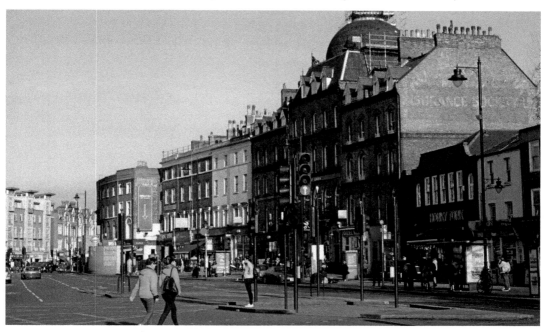

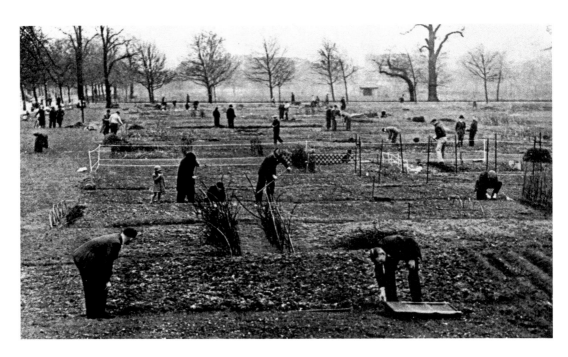

Allotments on the Common

During the Second World War the appearance of Clapham Common was completely transformed by allotments, army installations and then by temporary housing. Much of the UK's food was imported before the war, so that restrictions on shipping meant there was an urgent need for home-grown food. All over London open spaces from parks and commons to strips of land beside railway lines were turned over to vegetable growing, encouraged by the 'Dig for Victory' campaign.

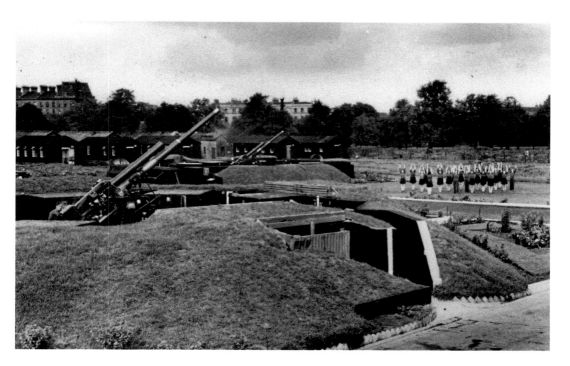

## Anti-aircraft Guns on Clapham Common

The large anti-aircraft base on Clapham Common during the Second World War included Nissen huts for gun crews, ammunition bunkers, searchlights and sound locators. The Women's Auxiliary Air Force was based here, and their quarters included a chapel, as well as dormitories, a dining room and sitting room. In the top picture the women can be seen exercising, and the distinctive roof of the eastern Cedars Terrace appears in the top left-hand corner of both pictures.

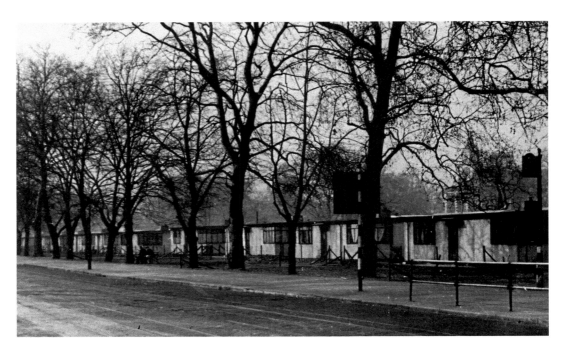

### Prefabs in Long Road

Clapham suffered badly from bombing during the Second World War, and the destruction of housing meant that many were homeless. Prefabricated houses, known as 'prefabs' were quickly erected on open spaces to provide instant family homes. Clapham Common had rows of these along Long Road and on South Side. Despite a huge house-building programme after the war, and the fact that they were only intended as short-term housing, the prefabs in Long Road survived until 1955. A few can still be seen today in parts of South London.

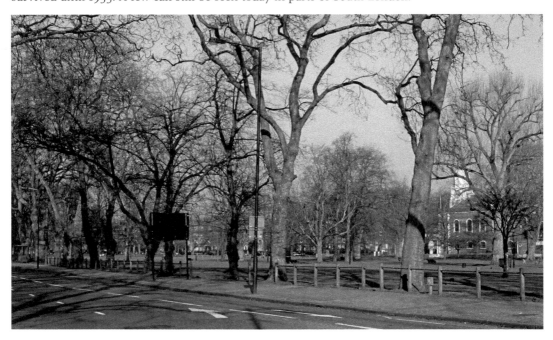

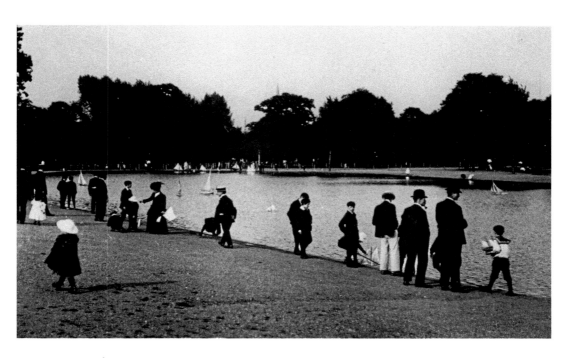

## Long Pond

There were once at least eleven ponds on the Common, and probably more – some natural and others created by digging for gravel to make nearby roads. Now there are four. The ponds have changed their uses at various times, but this one near Rookery Road has been used for model boats since the 1870s. There is still a model yacht club, one of the oldest in the country, which holds regular events. On Sundays only model yachts and sailing boats are allowed and powered boats on other days. Petrol- and inflammable-fuelled boats are not allowed.

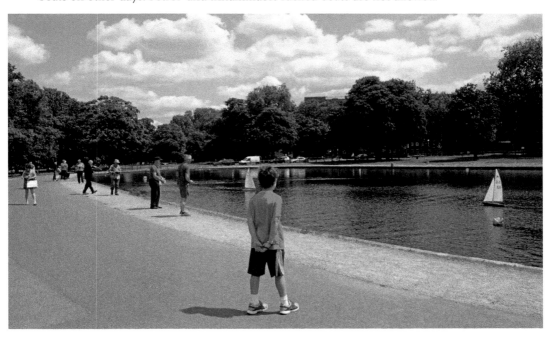

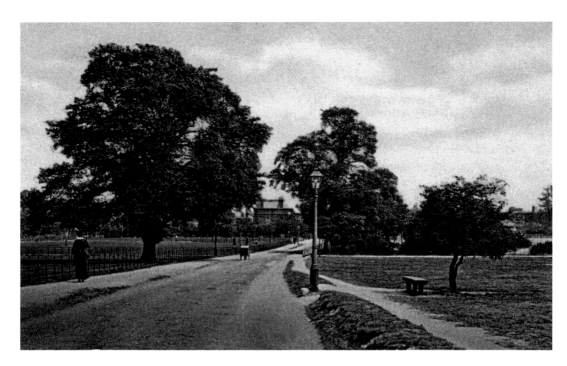

## Windmill Drive

This was a quiet lane across the Common until the motorcar took over. There have been various attempts to close the road to through traffic which is a particular hazard to children playing on the Common, but this has never been achieved. The shrubby area in the background, which has been a green refuse area for many years, is now being transformed into a community food-growing space, and a polytunnel has just been installed.

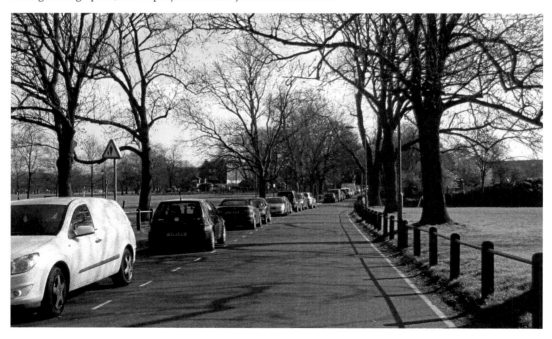

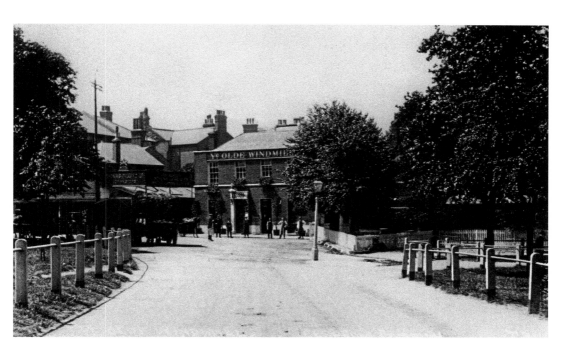

## The Windmill

A mill and house on this site are mentioned in a lease of 1631. The Windmill Inn is first recorded in the early eighteenth century, and this building dates from about 1790, though it has had several alterations and additions since. The inn, owned by Young's Brewery, was one of the last to which their beer was delivered by horse-drawn dray from their Wandsworth Brewery. The Windmill was originally a coaching inn, modern rooms have now been added and it is a small hotel, as well as a popular drinking destination for visitors to the Common.

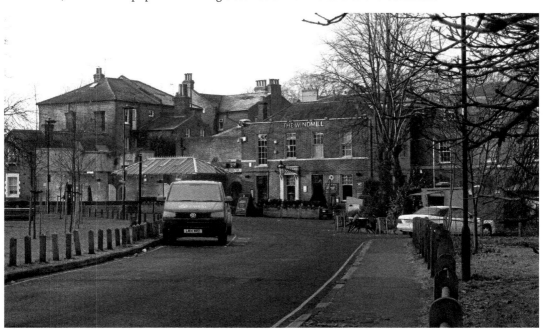

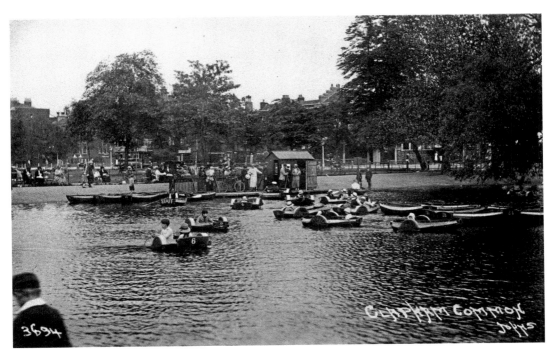

### Eagle Pond

So-called because it was opposite Eagle House on South Side, like the other ponds on Clapham Common, Eagle Pond has changed its use over the years. It is seen above in the 1920s as the boating pond, with the kiosk for purchasing tickets in the centre of the picture. There is now no pond on the Common where boats can be rented. In 2010–11 reed beds were planted around the banks, and it is one of the angling ponds.

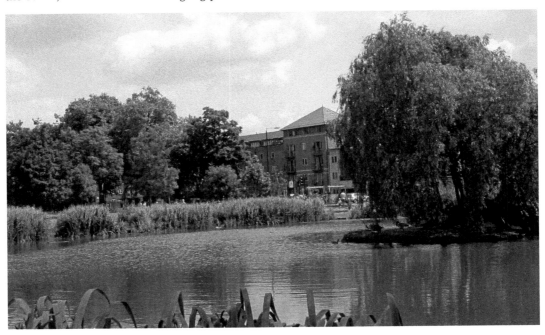

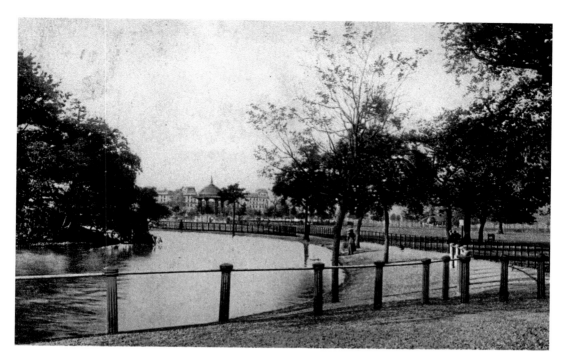

### Mount Pond

The 'mount', seen on the extreme left of both pictures, is a small island made by local banker, Henton Brown, in the 1740s. He built a bridge, erected a summerhouse on the island and kept a boat on the pond, treating it as his private property. Local residents soon put a stop to that! This is now the most popular pond on the Common with anglers. A restoration project in 2010–11 included the planting of reed beds, which have flourished and greatly enhanced the pond.

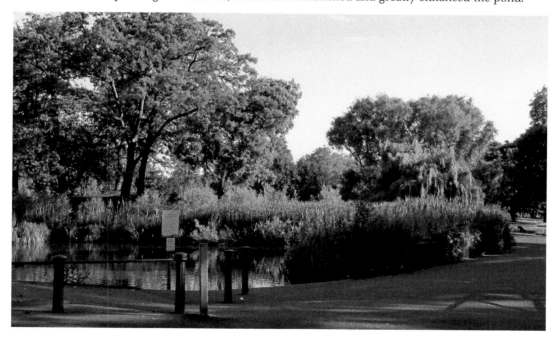

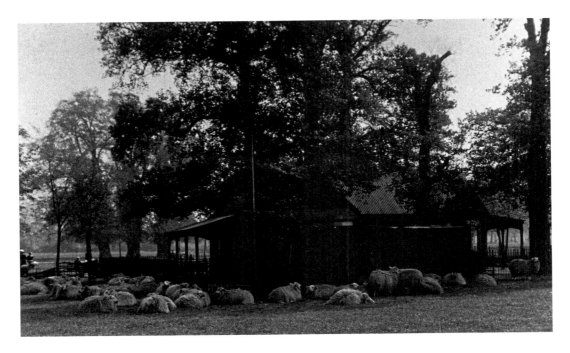

### Sheep on the Common

This picture dates from around 1910, when it was still not unusual for residents to exercise their ancient rights to graze sheep on the Common. The refreshment hut shown in the top picture was slightly to the north east of the present café near the bandstand, which replaced it in 1925. The new refreshment house was an elegant dining room with white damask tablecloths and starched table napkins. Since the 1950s, it has been closed for long periods and neglected, but for several years now has been the lively and successful La Baita café.

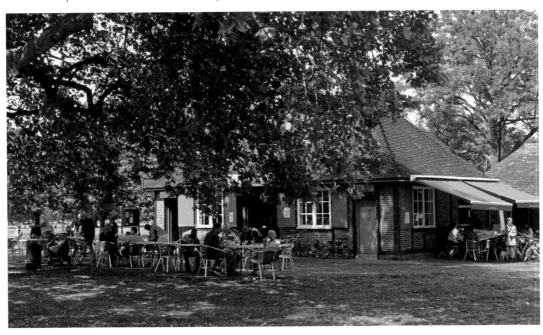

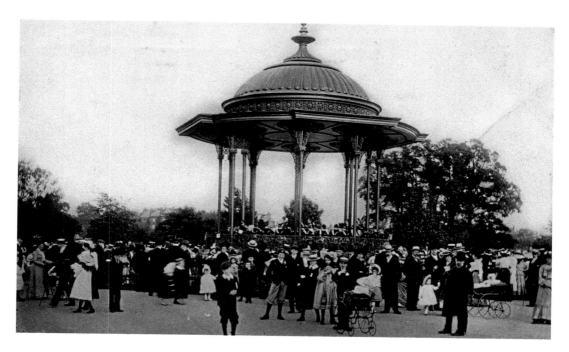

## The Bandstand

For many years it was thought that the bandstand on Clapham Common was one of the two designed in 1862 for the Royal Horticultural Society's gardens in South Kensington and removed here when the gardens closed. However, research by local historians has proved that Clapham failed to get one of these, so in 1890 a replica was commissioned. By 2000, the bandstand was in lamentable condition and on the English Heritage 'at risk' register. After energetic local fundraising, which gained the support of the Heritage Lottery Fund, the bandstand was beautifully restored in 2005–06 and is once again in regular use throughout the summer.

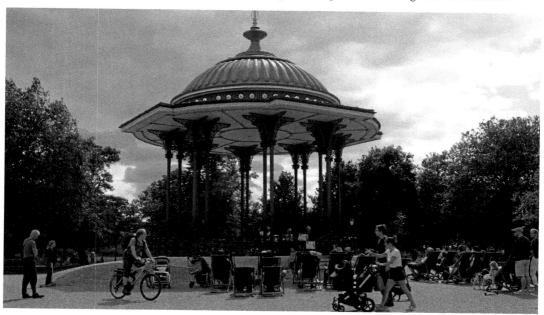

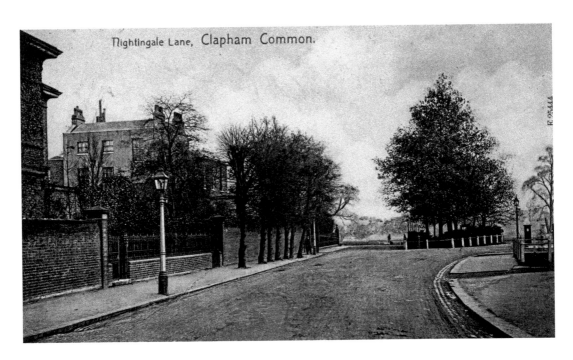

Nightingale Lane, Clapham Common.

## Hightrees House

At the south-west corner of Clapham Common stands Hightrees House, an imposing block of flats built in 1937–38 in the then-emerging 'international' style by the architect Richard William Herbert Jones, better known for his hotel and lido at Saltdean. The 110 flats were ultra-modern and there was a communal bar, restaurant and swimming pool. The Second World War however made the flats difficult to let, and after the war the rentals were the subject of a ground-breaking legal decision by the celebrated judge Lord Denning.

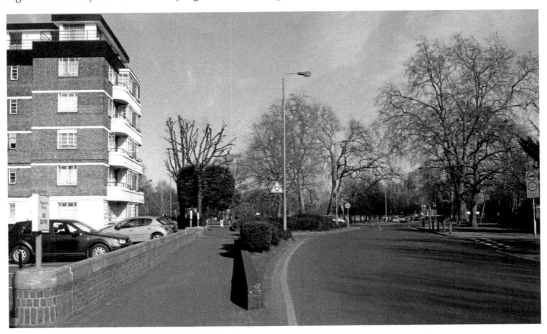

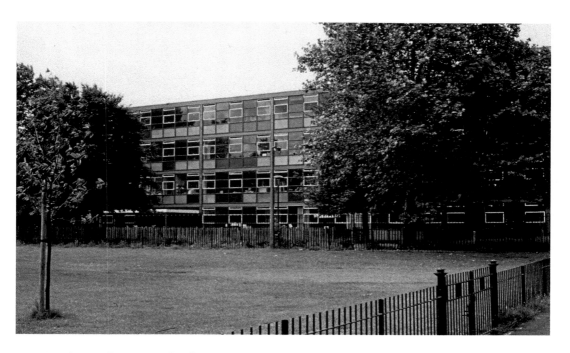

### Marianne Thornton School

In 1960 this London County Council Secondary School for Girls replaced some West Side villas and their long gardens. The striking building, shown above, with full height glazing to the four floors of classrooms and semi-enclosed courtyards behind was named after Marianne Thornton of nearby Battersea Rise, whose great-nephew E. M. Forster had recently published her biography. The school joined with Clapham County School for Girls in Broomwood Road (now Thomas's Clapham) to form Walsingham School in 1976. It was closed and the building demolished in 1997, when the present houses were built in the style of the adjacent terrace.

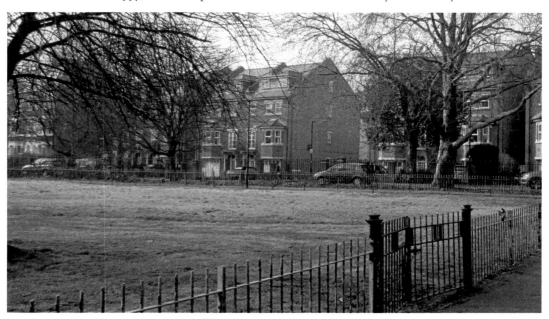

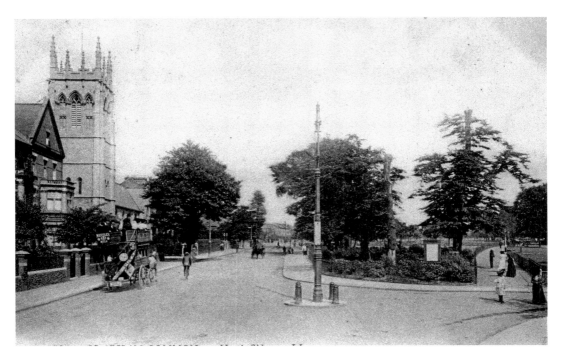

### St Barnabas Church

In 1898 St Barnabas Church was built on the front garden of the splendid eighteenth-century mansion, The Shrubbery, totally cutting off the house from the Common. The Shrubbery survives, now converted to flats, with its entrance behind the church in Lavender Gardens. Among past residents was the Greek merchant, Michael Spartali, whose two beautiful daughters modelled for artists, Edward Burne-Jones, Rossetti and Whistler.

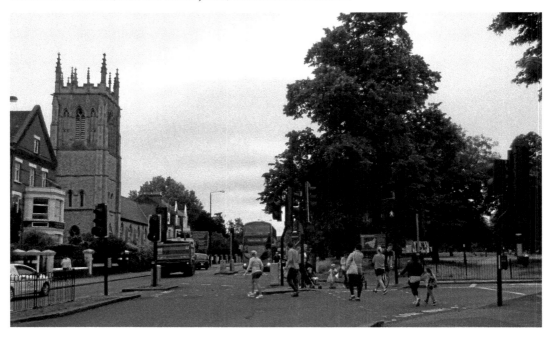

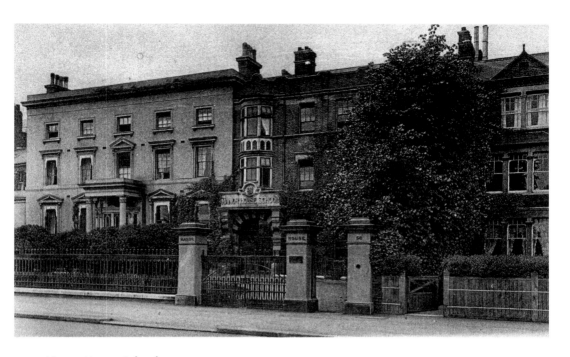

## Manor House School

There has been a school on this site since 1906 when Manor House School for Boys moved here from Clapham Old Town. The school was founded there in 1876, by Dr Maxwell, whose son later took it over. The red-brick and stone extension to the right of the stuccoed eighteenth-century mansion was added in 1905–06. In 1948 the premises became Battersea College of Domestic Science, eventually closing in the late 1970s when it became part of South Bank Polytechnic. As Eaton House The Manor the school has added several buildings behind on the original gardens, including a theatre in 2013.

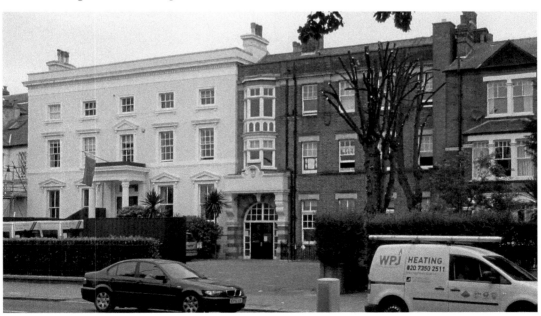

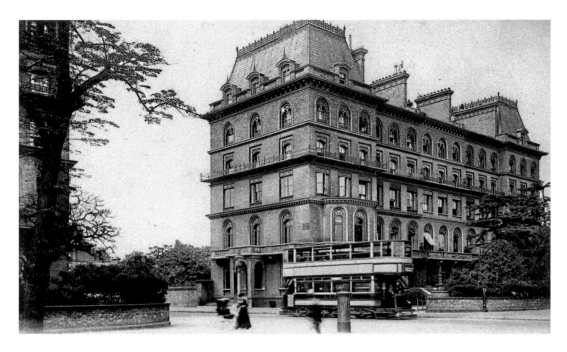

## Cedars Terrace

The two massive French Renaissance-style terraces which flank Cedars Road were built in 1860 by the local architect J. T. Knowles junior (1831–1908). They were planned as the gateway to a development which was to extend right down to the river, but this was never completed. Originally designed as houses, these terraces are now divided into flats and much of the elaborate decoration to the balconies has recently been restored, particularly on the western terrace. A blue plaque on No. 47 records a frequent visitor, the Norwegian composer Edward Grieg.

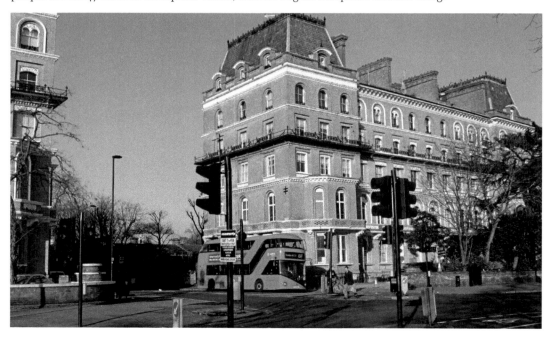

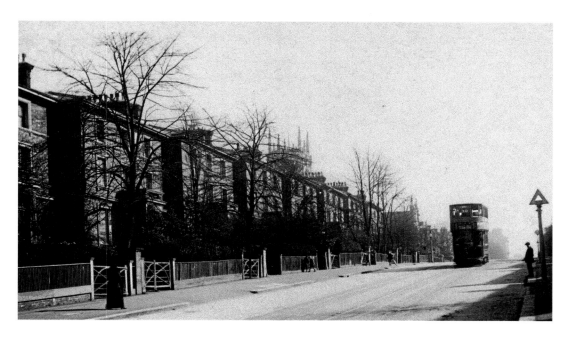

### Cedars Road

Rather controversially almost this entire street of large detached villas, designed by architect J. T. Knowles junior in the mid-1860s, was demolished following bomb damage to some of the houses in the Second World War. Just four of the original villas on the western side of the road now survive. The church, St Saviour's seen in the centre of the top picture which was situated between Cedars Road and Victoria Rise, was damaged beyond repair and not replaced. The white-brick maisonettes of the LCC Cedars Road Estate built in 1961–68 are on the footprint of the original villas, with connecting walkways and communal courtyards.

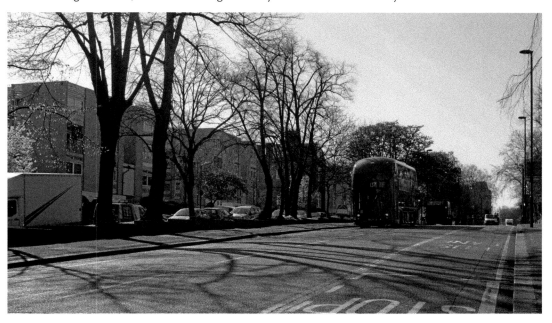

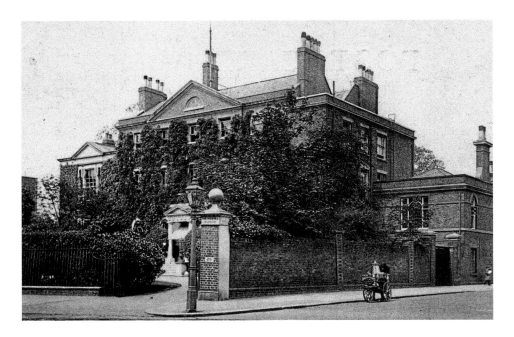

## Trinity Hospice

The large mansion, No. 30 Clapham Common North Side built in 1754, has been home to banker Robert Barclay and to Sir Charles Barry, architect of the Houses of Parliament, who is commemorated with a blue plaque. In 1899 it was purchased for the Hostel of God, a home for the terminally ill, originally run by sisters of charity. Over the years adjoining buildings were purchased and the name was changed to Trinity Hospice. In 2009 a purpose-built block was added behind and the award-winning garden – which is regularly open to the public – restored. In 2015 the upper floors of the house, which no longer comply with health care regulations, are being converted to six flats.

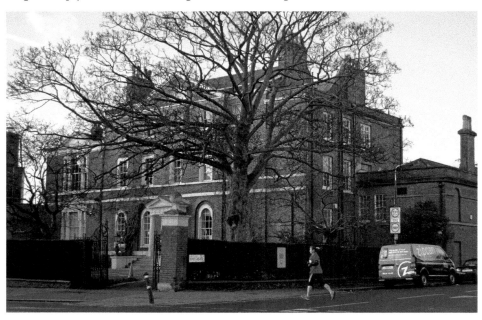

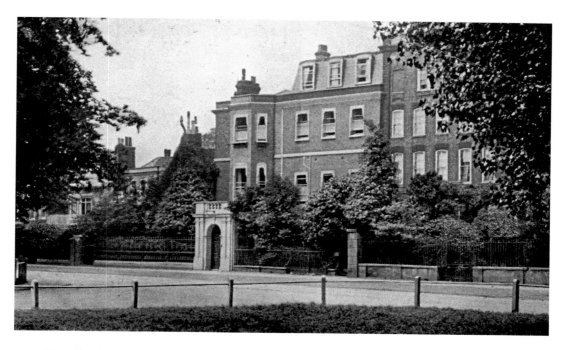

## Woodlands

This postcard *c.* 1913 captioned 'Guest House of the Cooperative Holidays Association' shows, on the right partly hidden by a tree, the original end of the Georgian terrace, church buildings (Nos 23–12 North Side), and the adjoining pair of Victorian houses (Nos 24–25). When the 200-year lease on the terrace expired in 1913 plans for Westminster Hospital to demolish the houses and rebuild on the site were halted by the outbreak of the First World War. The buildings became neglected, and Nos 25–22 had already been demolished, when restoration of the rest of the terrace began. The present Woodlands and adjoining Okeover Manor were built in 1934–35.

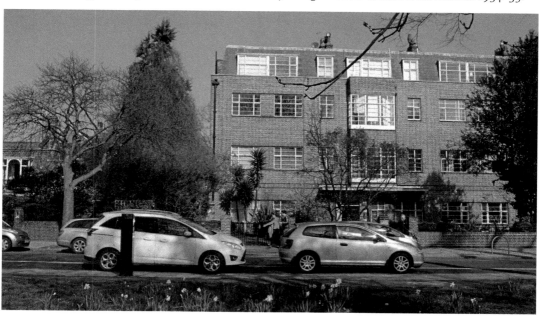

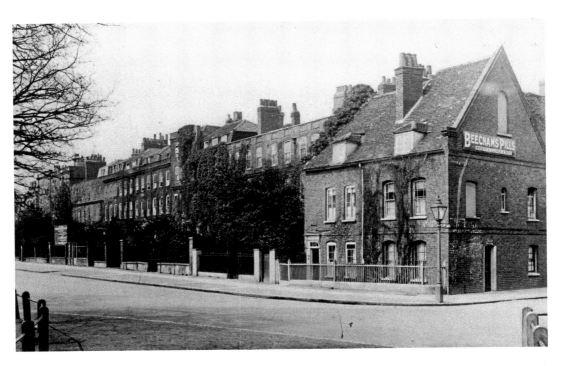

### Nos 10–11 Clapham Common North Side

Parts of the pair of cottages shown above date back to the seventeenth century making them among the earliest buildings in Clapham. They have been much altered and were re-fronted in around 1700. One of the pair, No. 10, was demolished for the widening of Macaulay Road in the 1930s, probably for easier access at the time the factory next to the Parochial School was built. To the left can be seen Church Buildings.

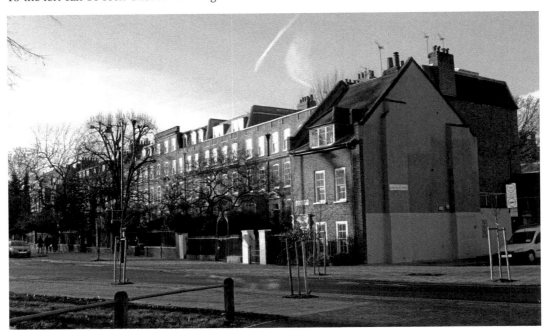

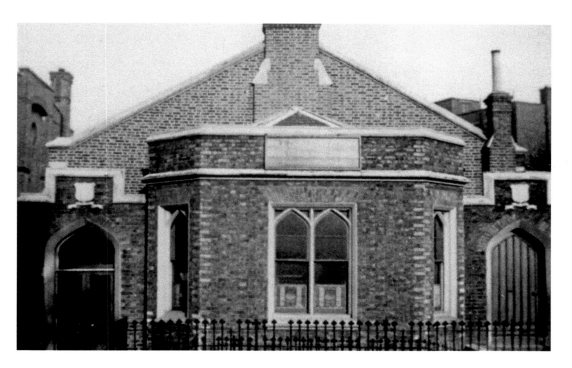

Clapham Parochial School, Macaulay Road

The school was built in 1838 as an annexe to the original Parochial School in Old Town, on land purchased from the Lord of the Manor by a local benefactor. It was originally one large room, which was also used for public meetings. Shown above in the 1930s it continued in use as part of the renamed Macaulay School until the 1970s when the new school was built in Victoria Rise. After a period in office use, the building was converted to a private residence in 1999.

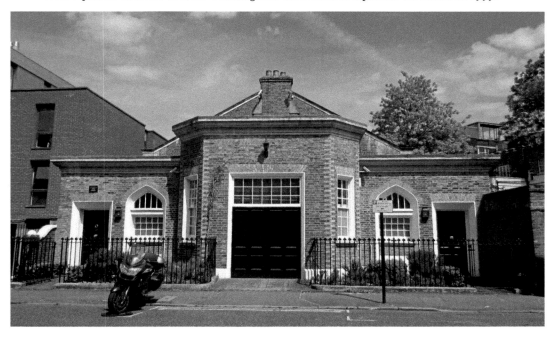

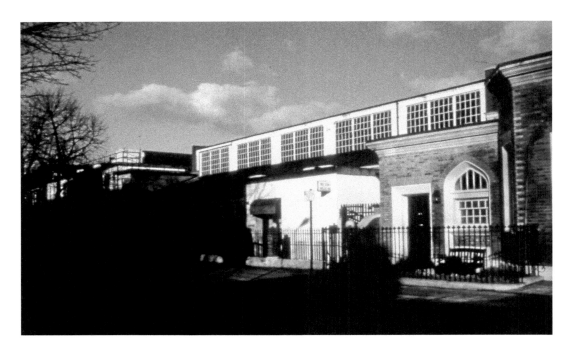

## Cannons Factory

In the 1930s a two-storey factory block was built adjoining the Parochial School. For many years it was occupied by Cannons, distributors of motor spares and accessories. When the company moved out of Clapham in 2007 the factory was demolished and two Victorian houses as well as six warehouses behind, which had belonged to Ross Optical, were added to the site. These were incorporated in the mixed-use scheme comprising ninety-seven residential units and 30,000 sq. feet of commercial space named Macaulay Walk, which was completed in 2014.

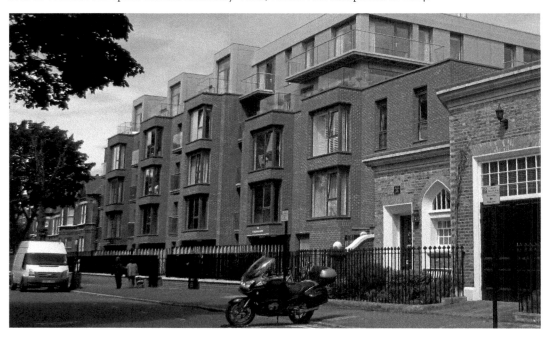

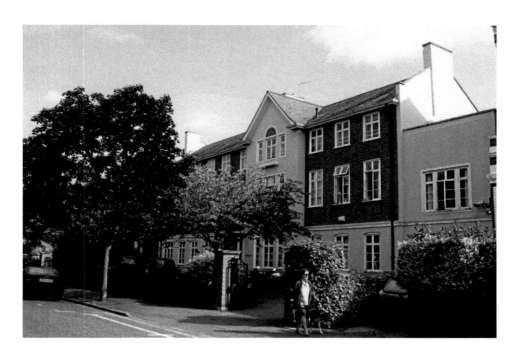

## Osborne House

Bomb damage at the northern end of Macaulay Road resulted in post-war rebuilding of one house on the west and this small office block on the east side, in 1957. For several years it was home to the specialist conservation builders, Kilby and Gayford. In 2015 the block was replaced by three six-storey town houses by architect Michael Squire, a long-term resident of the road and one of the architects of the Chelsea Barracks redevelopment. One of the new houses is now his family home. The six-bedroom houses have a basement set below a lower ground floor and stone-clad cantilevered balconies.

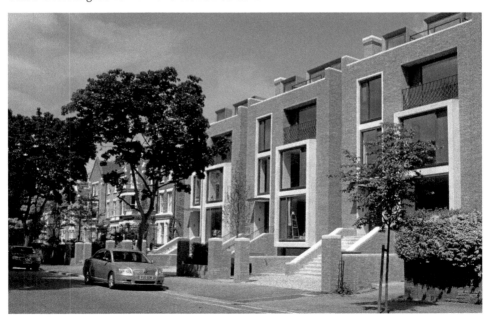

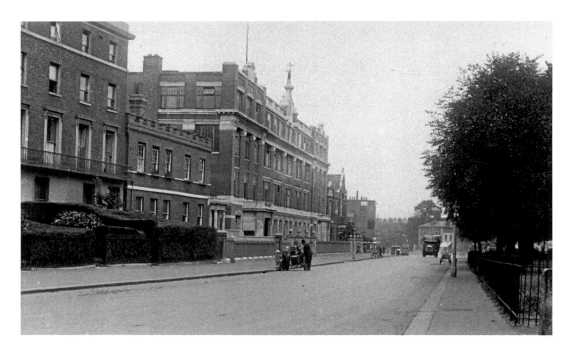

## Ross Optical

In 1915–16 a new factory was built at Nos 2–3 Clapham Common North Side for Ross Optical, makers of lenses and optical equipment, to replace their earlier factory on the site. The intention was to extend industries which had hitherto been dominated by Germany. In 1998–99 architects Allies Morrison stripped out and converted the building to contemporary office space, adding rooftop pavilions, for locally launched address management software company QAS, now part of Experian. In the distance of the bottom picture is Maritime House, built in 1939 as headquarters for the National Union of Seamen.

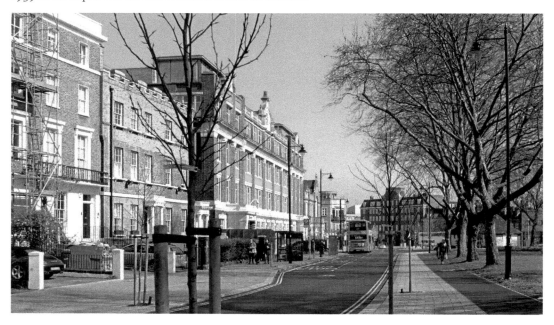

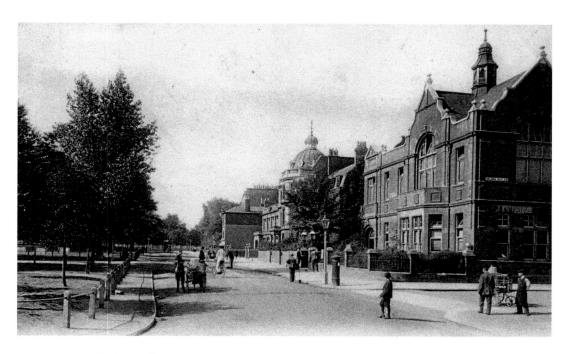

### Former Clapham Library

The library designed by the local architect Edward Blakeway I'Anson was opened in 1889 by Sir John Lubbock, Vice-Chairman of the London County Council and a strong advocate of free libraries. In 2012 a new library was built in Clapham High Street and this building was saved by local enthusiasts to be converted to Omnibus Arts Centre. It was opened on 31 October 2014 by Lord Avebury, grandson of Sir John Lubbock, on the 125th anniversary of the original opening of the library. In the centre of the picture is the dome of the former Ross Optical building which was replaced by the new building (now Experian) in 1915–16.

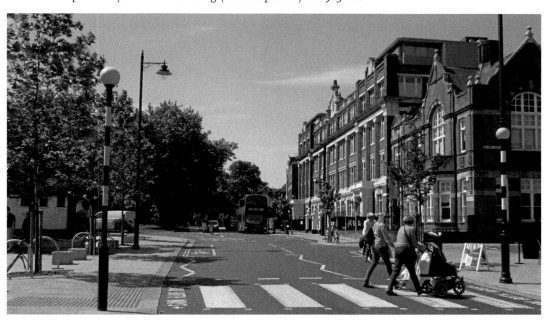

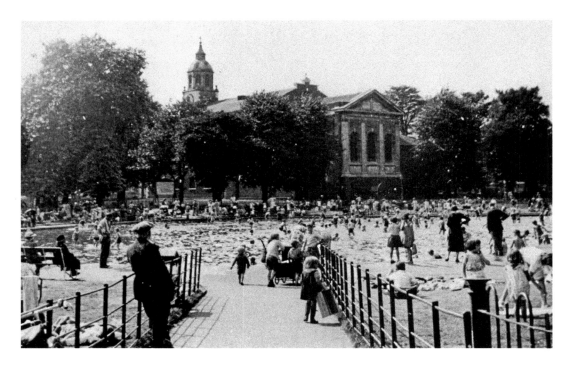

## Cock Pond

This is the pond on Clapham Common which has long been the one where children can play in the water. Seen above in the 1930s crowded on a summer day, it is now rarely as busy. In 2003 the pond was repaired and painted, but on safety grounds only a very small amount of water is now allowed and for a limited time in the summer; it is usually emptied at night. In the distance is the east end of Holy Trinity Church.

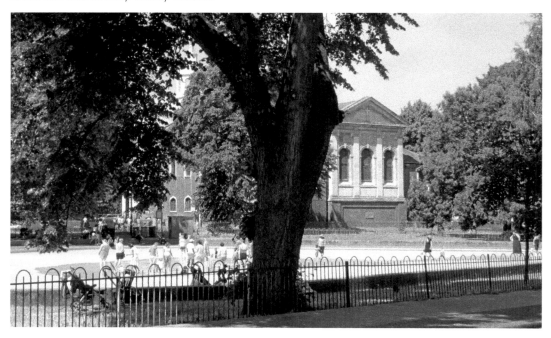

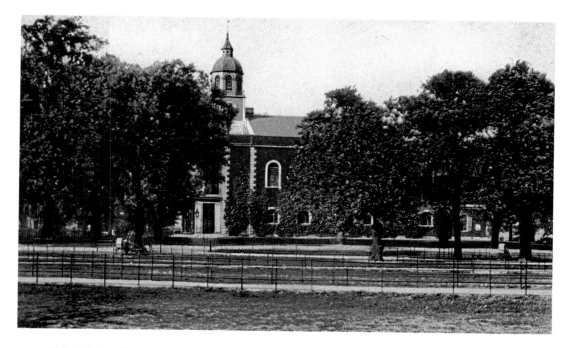

## Holy Trinity Church

This church (Grade II listed) was built in 1774–76 to replace the original parish church in Rectory Grove, in disrepair and inadequate for the growing population of Clapham. The architect was Kenton Couse, who had recently rebuilt the frontage of No. 10 Downing Street. The porch was added later to give shelter to those arriving in their carriages. The church is best known for its connections with William Wilberforce and the Clapham Sect whose campaigning brought about the abolition of the slave trade. Their names are listed on a plaque on the south wall, which was damaged in the Second World War and has been left unrestored.

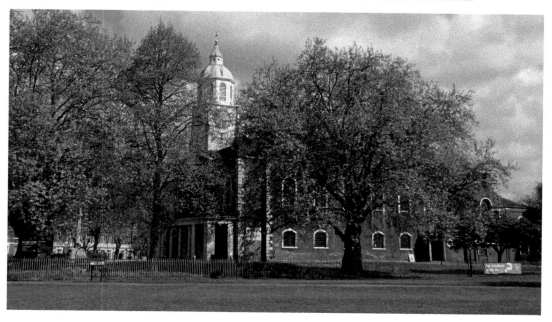

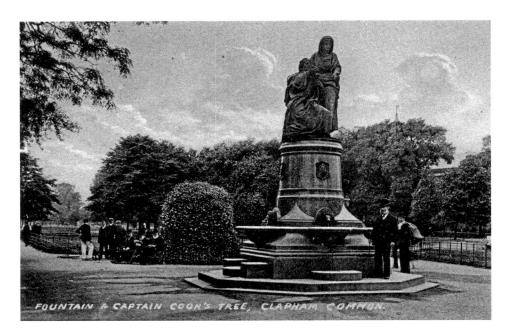

FOUNTAIN & CAPTAIN COOK'S TREE, CLAPHAM COMMON.

Temperance Drinking Fountain

The drinking fountain depicts a woman giving water to a beggar. The bronze figure on a granite base is by German sculptor August von Kreling, and was cast in Munich in 1884. It was originally erected outside the head office of the United Kingdom Temperance and General Provident Institution at the northern approach to London Bridge, but when the weight began to crack the approach to the bridge it was removed to Clapham Common. On the left of the top picture is the stump of a tree known as Captain Cook's tree. It has no connection with the celebrated navigator who did not live in Clapham, though his widow lived in Clapham High Street from 1788 until her death in 1835.

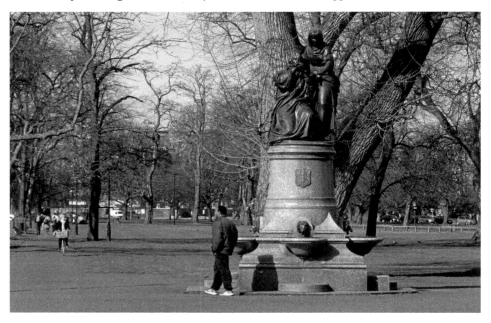

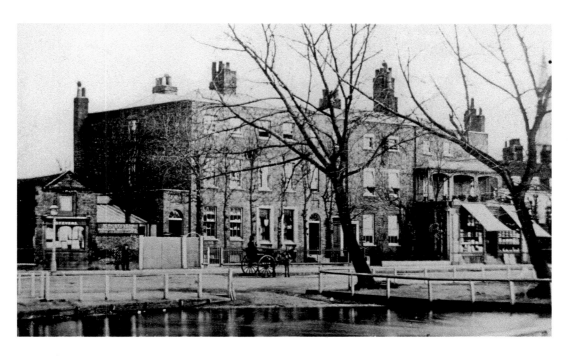

## The Pavement

The top picture of about 1860, by local photographer Henry Deane, shows the original residential Regency terrace (*c.* 1815) before various additions and rebuilds as a result of which all the former houses were converted to shops, and extended out over the small gardens. After falling in to disrepair in the mid-twentieth century the shops here have now been restored very sensitively to form an attractive row. The former Cock Pond opposite, originally for horses to drink, has for long been the children's paddling pool.

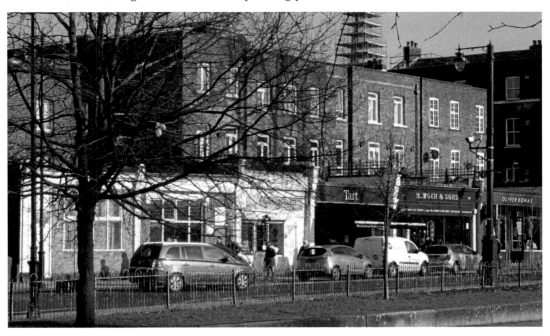

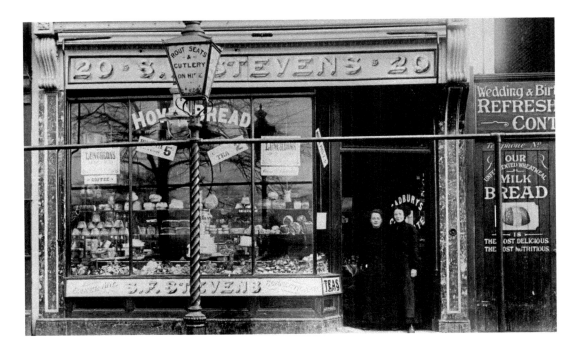

## Stevens Bakery

This once well-known family bakery started in Clapham North in 1876, moving to No. 20 The Pavement in the early twentieth century. As business increased, the garden was built on and adjoining premises bought. By the 1920s the bakery was working twenty-four hours a day, with ten modern ovens, and 104 employees making and wrapping bread and confectionery, and decorating wedding cakes. It became known as 'The Big Cake House' because each Christmas a multi-tiered iced cake filled the shop window. Rebuilt in the 1970s the building is now one of Clapham's many estate agents.

## Umbrella Shop

Several pictures of this splendid umbrella and walking stick shop at No. 8 The Pavement were recently sent to the Clapham Society by a descendant of the shop owner, Mr Miles. This photograph was taken in 1917, but the shop which opened in about 1900 was still here in the 1930s. Other pictures show the shop with a Christmas hoarding stretching the entire height of the building. It is now a Chinese restaurant.

### Deane's the Chemist

No. 18 The Pavement is the finest surviving shop in Clapham. It was built in 1824 as a grocer's and taken over in 1837 by Henry Deane, Chemist. The painted name still survives – just – on the upper part of the eastern flank wall. Henry Deane was a pioneer local photographer whose photographs, several of which are used in this book, are the earliest of the area. The shop survived as a chemist until the late 1980s, and retained many of the original fixtures and fittings which, along with the building itself, are Grade II listed.

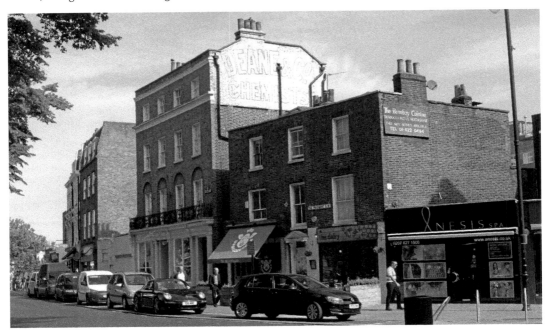

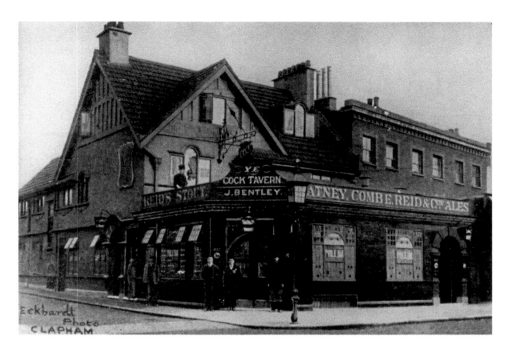

### The Cock Tavern

Parish records mention the Cock Tavern on this site as early as 1722, and it was one of the three original inns of Clapham – the others were The Windmill and The Plough (now Stane St Syndicate bar). It was totally rebuilt in 1903, as shown above, and again much altered in the 1990s when the traditional name was lost. A recent refurbishment has mainly restored the 1903 appearance, though not the traditional name. It was fortunate to escape damage from the Second World War bombs which destroyed nearby buildings.

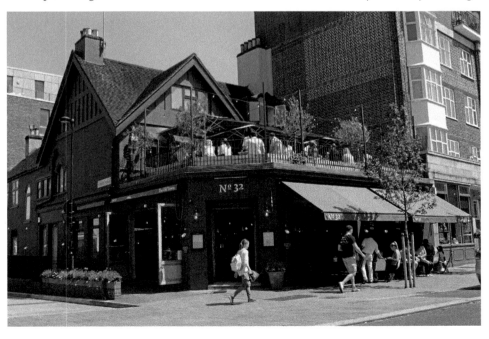

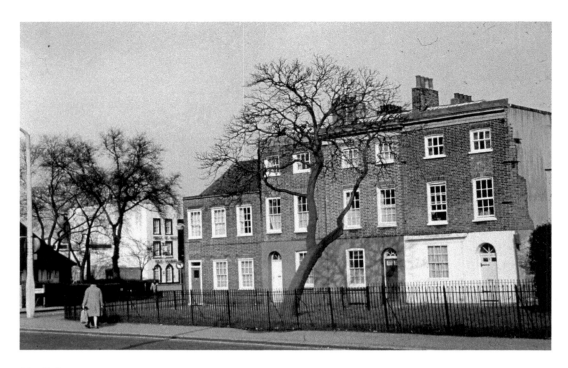

## The Polygon

The three central houses of this group on the south side of The Polygon have survived more or less as built in 1792, and their neighbours have been rebuilt sympathetically. Between the top picture of 1976 and today's the surrounding area has been pedestrianised, more of The Polygon has been rebuilt and shops with apartments over have appeared on the corner of Orlando Road next to The Prince of Wales pub, which stands alone in the distance in the top picture.

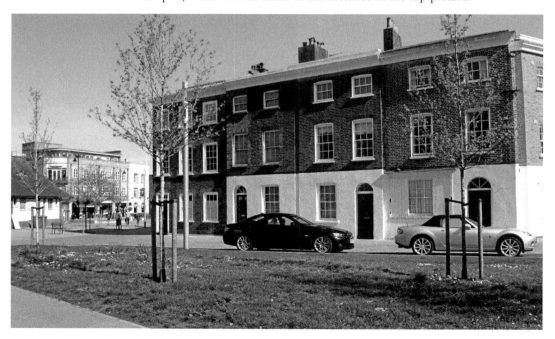

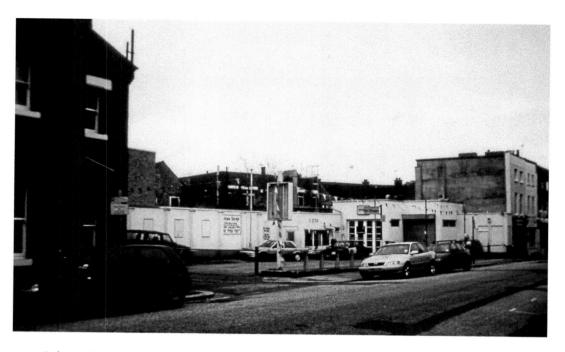

## Polygon Garage

The Polygon suffered badly from the Second World War bombing, and almost the entire east side was completely destroyed. Parts of the western side were rebuilt in the 1950s but for many years this site on the south-east corner was occupied by a garage and second-hand car dealer. It was not until 2001–02 that it was finally rebuilt and shops – almost exclusively estate agents – opened. In the 2014 refurbishment of the area the road was narrowed, made one-way and a controversial contra-flow bicycle lane introduced.

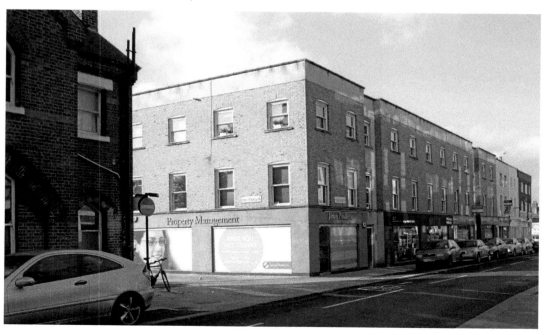

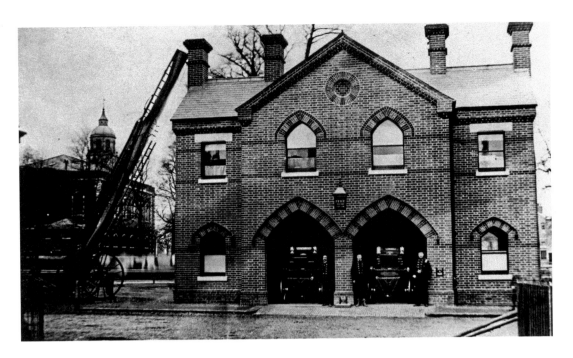

## Old Fire Station

The original building on this site was the parish lock-up for drunkards, vagrants and thieves, and later housed the parish fire engine. In 1866 the Metropolitan Fire Brigade was formed to take over responsibility from London parish and other independent brigades. Clapham Fire Station, pictured here in 1869, was one of twenty-six built for the new brigade. By 1902 this fire station was too small and was replaced by a new one on the corner of Old Town and Grafton Square. This building, for some time the Common Keeper's Lodge, is now in private residential use.

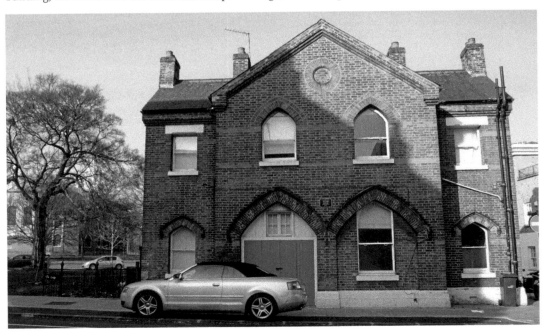

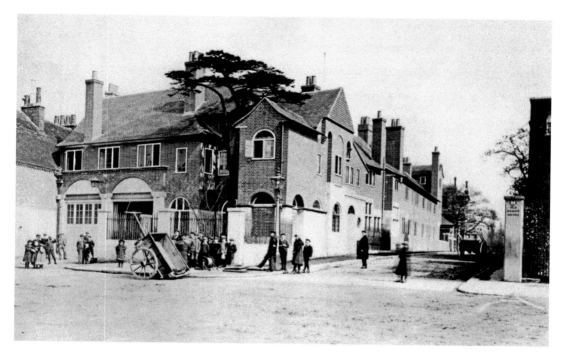

## Fire Station

This fire station was built in 1902 to replace Clapham's original fire station near The Polygon which had become too small. In its turn this too was considered too small by the 1960s and was replaced in 1964 by a larger fire station, able to accommodate four fire engines. In 2014 when the number of London fire stations was being reduced Clapham Fire Station was threatened with closure, but following a vigorous local campaign it survived by being reduced to two engines again.

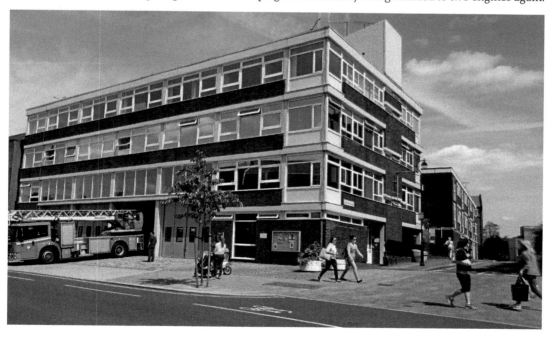

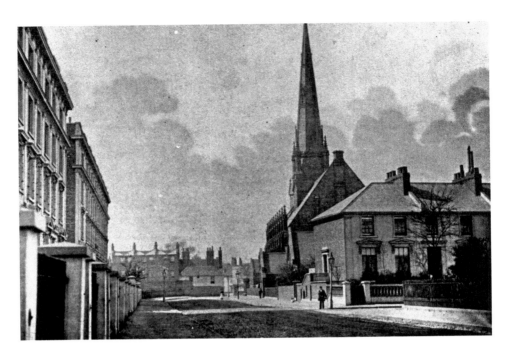

## Grafton Square

Seen here *c.* 1860 in a photograph by local photographer, Henry Deane, the north-west corner of Grafton Square was dominated by the Congregational Church of 1851–52. The church was damaged by a flying bomb in 1944 and later demolished to be replaced in the 1960s by the United Reformed Church, now Maranatha Ministries Worldwide Centre but invisible in the picture as it is set back from the road. The terrace opposite the church also demolished following war damage was not rebuilt until 2012.

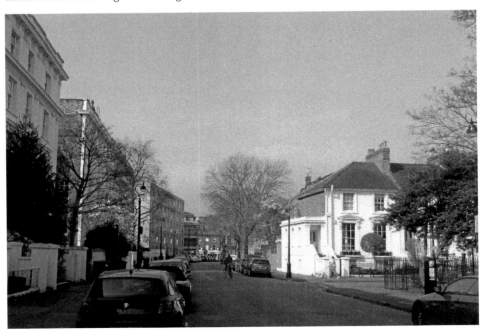

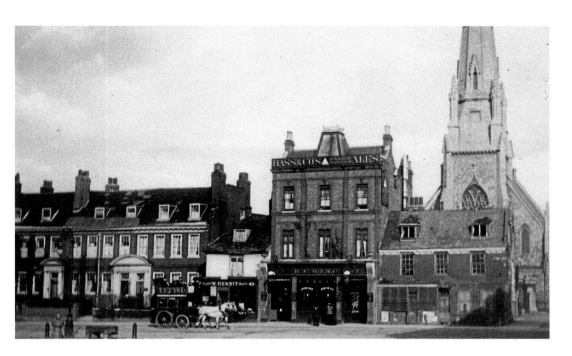

## Old Town

The three Queen Anne houses (Grade II listed) on the left of both pictures are among Clapham's finest houses, whilst the adjoining small cottage hidden in the lower picture is one of the oldest, dating from the late seventeenth century. The shop to the right of The Sun public house was destroyed by the bomb which demolished the church behind and the empty site is now The Sun's private garden. In 2014 the central area of Old Town, which had become run down over the years was refurbished as a new pedestrianised square.

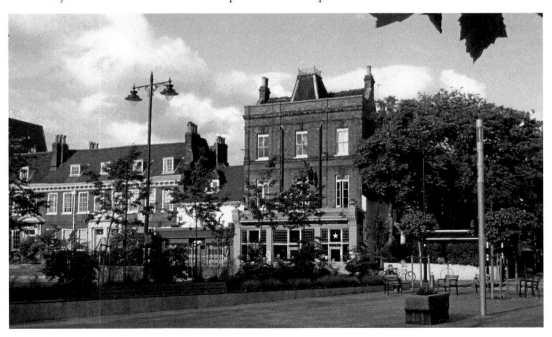

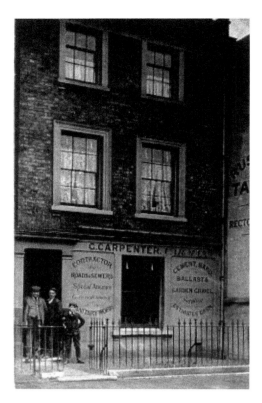

### Rectory Grove
This photograph, taken in about 1907 was recently sent to the Clapham Society from New Zealand by Graham Carpenter, a descendant of the Carpenter family whose construction business was based at this address in Rectory Grove, with a cobbled yard behind. In the days before planning permissions and distinction between business and residential premises, small terraced houses with painted signs advertising the business would have been very common.

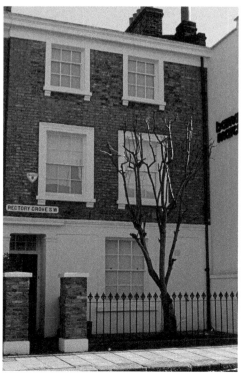

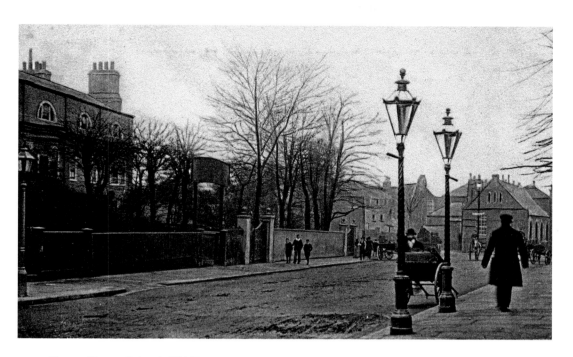

### Manor House School, Old Town

The eighteenth-century house on the left of the top picture, which was very similar in style to its surviving neighbour Sycamore House, was originally the home of George Griffin Stonestreet a founder of the Phoenix Assurance Company. In 1876 Manor House School was opened here by Dr Maxwell. The school moved to Clapham Common North Side in 1906 when the house was demolished and the existing short terrace, The Gables, was built. On the right of both pictures is the site of Clapham's first school, founded in 1648, since much rebuilt and altered but still in educational use as the Lambeth City Learning Centre.

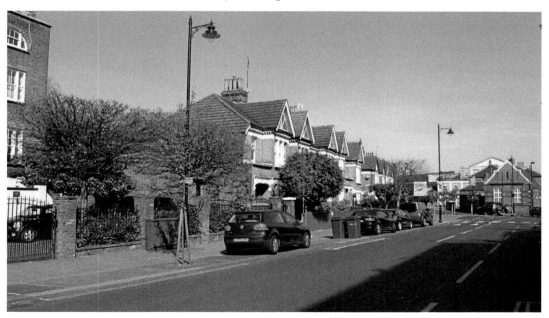

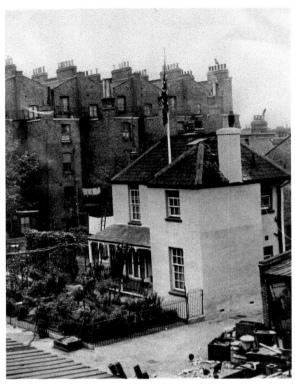

### Lease-Lend Cottage, Hannington Road

This site was empty until 1943 when it was given to Mr Hancock by someone whose life he had saved. Lacking the funds to pay a builder he collected salvage from bombsites with his motorbike and sidecar and built the house himself, at a cost he claimed of '£82 and not a penny more'. Lend-Lease was a Second World War scheme under which the USA provided war materials and services to allied countries without immediate payment, and it has been suggested that in a jokey reference to this Lease-Lend was a slang term for salvage collected from bombsites without payment. Subsequent owners made additions and alterations but the house survived with its garden and several garages, until 2010 when it was demolished and Wardell Mews was built on the site.

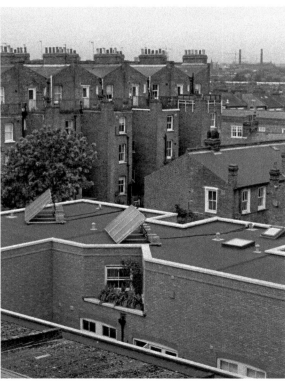

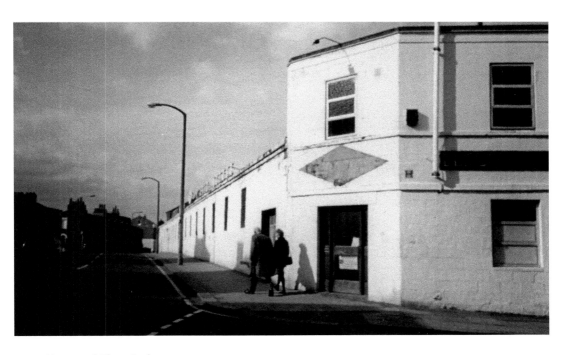

## Normand Electrical

Until the 1980s the Normand Electrical Company, manufacturers of geared motors, occupied this single-storey factory built in 1938. The picture above was taken shortly after they closed, and shows where their diamond shaped logo had been, over the entrance door. After various abortive plans to develop the site together with the adjacent Rectory Gardens, the factory was demolished in 1999 and a fitness centre opened the following year. The redevelopment also includes the gated residential mews, Floris Place, named after two local artists.

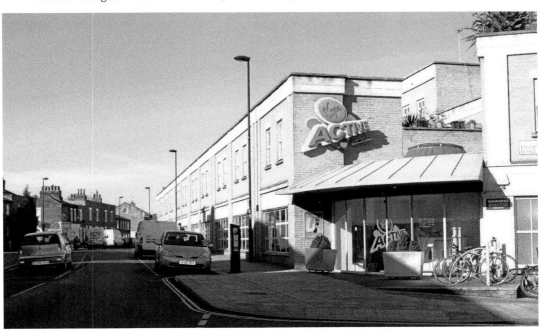

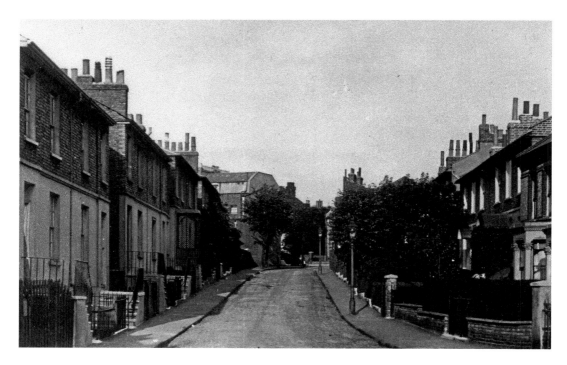

**Turret Grove**

This street derives its name from the Elizabethan manor house which was once on the site, and was demolished in 1837 for the building of these houses. At one end of the manor house was an unusual domed turret on an octagonal tower. These pictures show the change only too typical of residential streets in Clapham, where front gardens have been turned into off-street parking spaces.

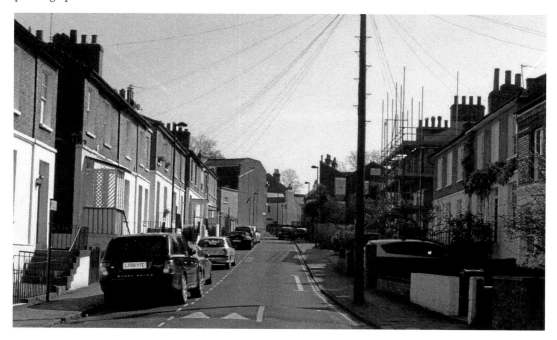

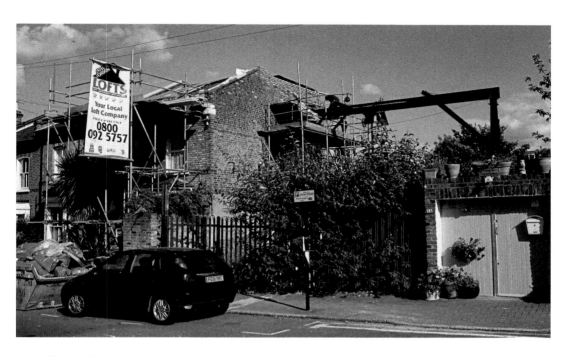

## No. 2a Turret Grove

Opportunities to build a new house in Clapham do not often occur. Originally a haulage company yard, this site was beset with legal wrangling over ownership for many years. Once resolved, architect Nick Yeates provided a contemporary solution rather than a traditional pastiche. A crisp cedar-clad box with projecting zinc bays jetties over a stock brick ground floor and basement to create a spacious five-bedroomed family house. Utilising the window rhythm and lines of the adjoining properties keeps the house in scale with its surroundings.

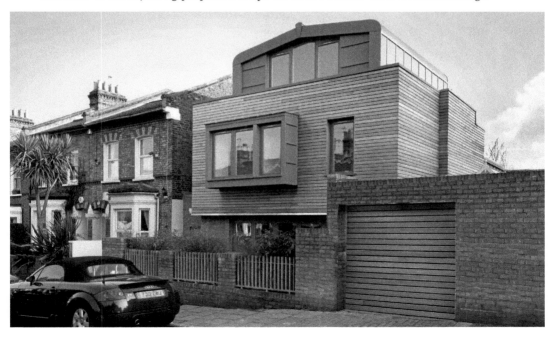

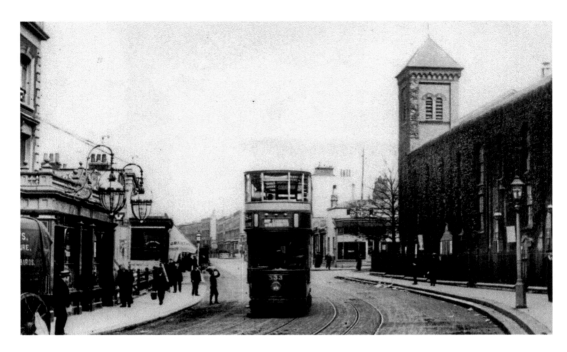

## Wandsworth Road Looking East

On the right of the picture, on the corner of Victoria Rise, is Clapham Baptist Church built in 1873. It was badly damaged in the Second World War and restored but without the towers that originally flanked the entrance. On the north side of Wandsworth Road (on the left in the pictures) is the Victoria public house, stripped of its former glory but being refurbished. Next to it is the former Temperance Billiard Hall, built in 1909 (after the top picture was taken), a bingo hall in the 1970s, later Riley's pool and snooker hall, and in 2015 being restored as a hotel.

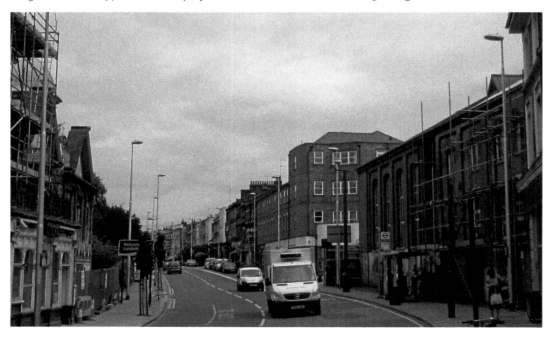

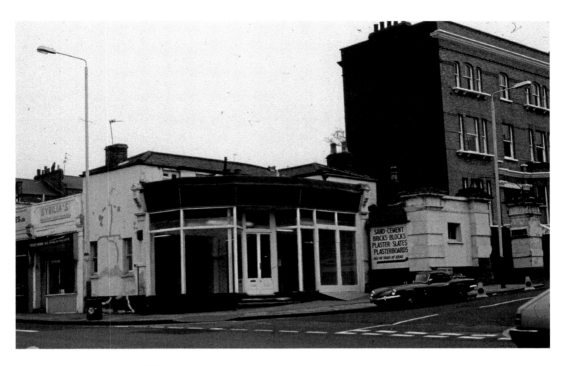

## Wandsworth Road/Victoria Rise

Behind the single-storey shops seen here shortly before their demolition in 1998 was a cottage, the side of which is just visible between two shop windows, and stables entered through gates on Victoria Rise. The stables were badly bombed in the Second World War and the site remained empty for over fifty years until redevelopment as shops with flats above. The one surviving gatepost in Victoria Rise can be seen on the extreme right of the picture below.

## Ingleton House

The two eighteenth-century houses on this site became a charitable boys' home in 1903, and a few years later a chapel and a refectory were added behind. At one time there were sixty teenage boys at the home, some working and others at school. The home moved to the country in 1938 and the building later became a local authority after care hostel for boys. In 1989 the houses were replaced by the present block of flats for a housing association. The chapel, which can be seen on the left of both pictures, survives and has recently been purchased by Clapham Pottery. Regular pottery classes are held here, and some of the original interior has survived.

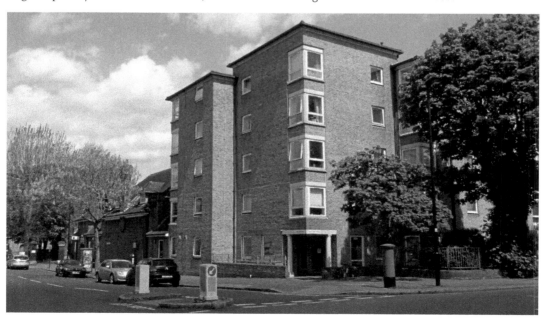

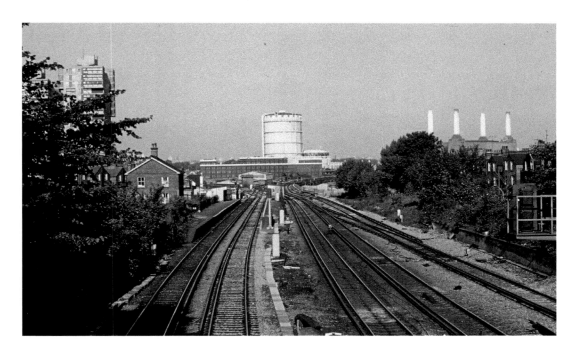

## Larkhall Railway Bridge

The bridge over the railway in Larkhall Rise has been a good place for train-spotters since the London Chatham and Dover Railway arrived in 1862. For many years, Wandsworth Road Station served the South London Line, a shuttle service from Victoria to London Bridge. It is now part of the Overground. The tracks on the right were part of the original route of the Eurostar trains in 1994. The gasometer which once dominated the distant view is being dismantled in 2015 as part of the huge redevelopment of Nine Elms, which also includes the rebuilding of the four chimneys of Battersea Power Station, just visible behind the trees.

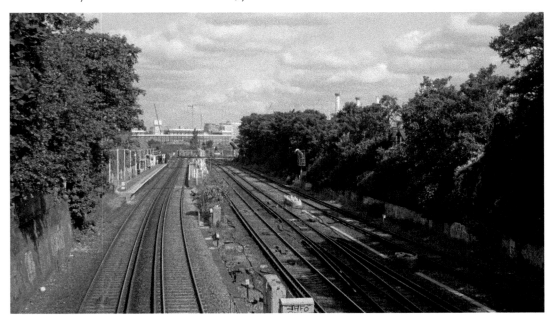

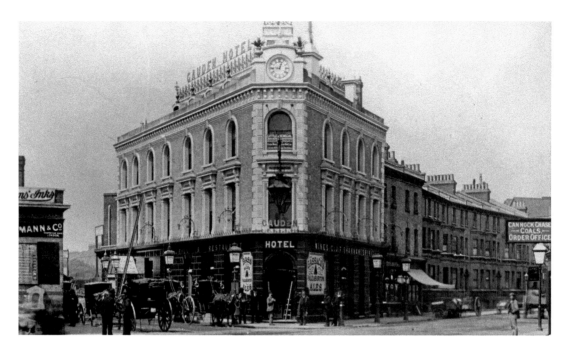

## Gauden Hotel

This large hotel on the corner of Gauden Road and Timbermill Way was badly damaged in June 1944 by a direct hit by a V1 flying bomb, commonly known as a 'doodlebug'. This pilotless plane used towards the end of the Second World War was especially frightening as one could hear it approaching and did not know where it would fall when the engine cut out. Ten people were killed in this incident and many others injured. The hotel was demolished and eventually replaced by mixed residential and commercial units.

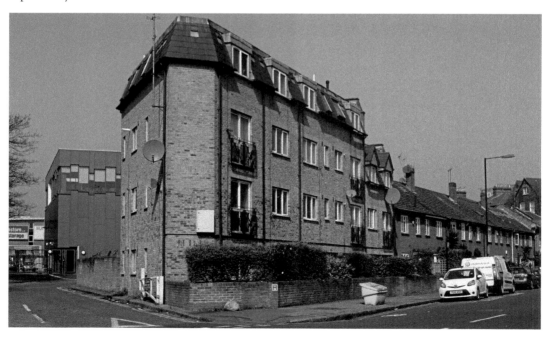

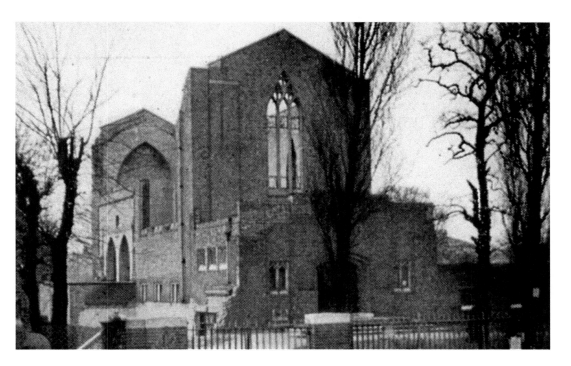

## St Bede's Church, Clapham Road

Edward Maufe, architect of Guildford Cathedral, built this church (1922–24) for the Royal Association for the Deaf and Dumb. The church was badly damaged in the Second World War, but much of the church hall beneath survived and services continued to be held there. The church was rebuilt after the war. It is now no longer a place of worship, but as St Bede's Centre for Deaf People offers a range of social and sporting activities for the deaf.

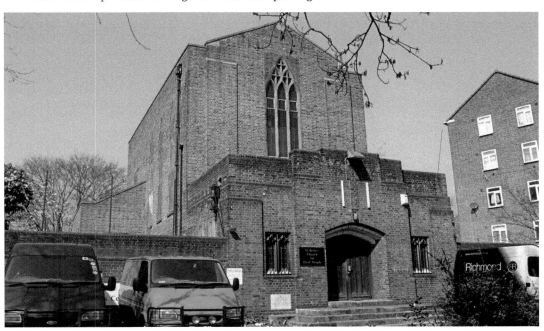

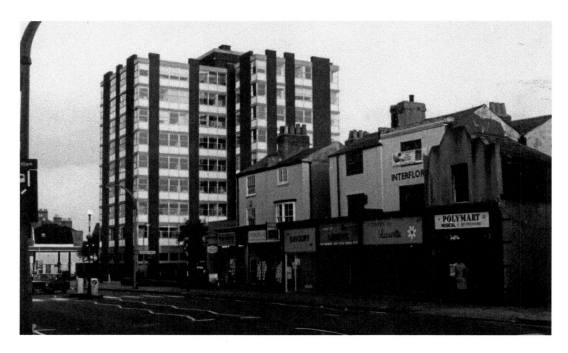

## Mary Seacole House

Mary Seacole House was built in 1968, initially as an office for Sainsbury's, later occupied by publishers, Weidenfield and Nicholson and then Lambeth Council. In 2012 it was replaced by The Library Building, a mixed-use development that includes a public library and health centre on ground floor and basement with 136 apartments across twelve floors above. Mary Seacole, a Jamaican-born woman of mixed race nursed sick and wounded soldiers independently in the Crimean War after the War Office refused to accept her services. She is celebrated as an opponent of racial prejudice, and the new centre retains her name.

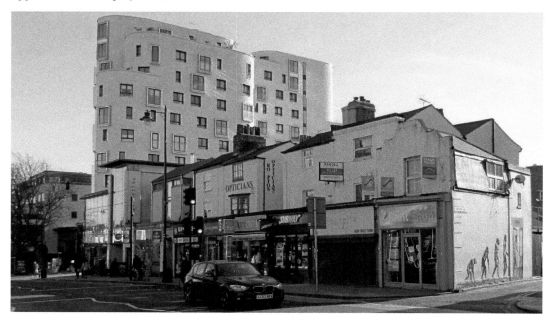

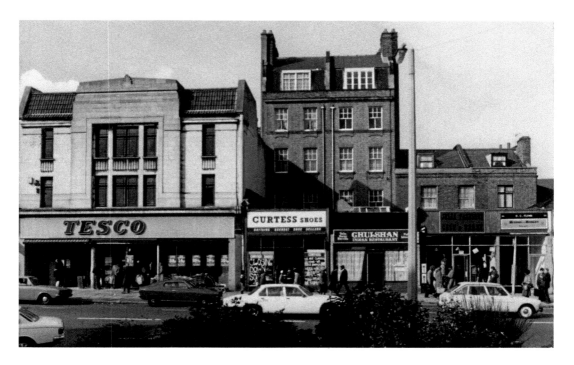

### McDonald's, Clapham High Street

Among the rows of terraced cottages with long front gardens – later built on for shops – which once stretched along Clapham High Street, this modern building was erected for Marks and Spencer in 1932. The store closed in 1945 and later Tesco's came and, nearly twenty years ago, McDonald's. The distinctive artificial stone façade with its long windows, only slightly altered, is clearly visible above ground level.

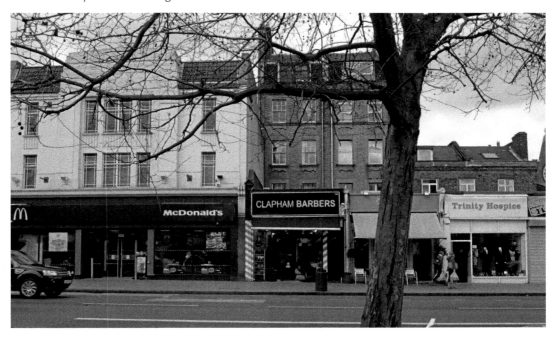

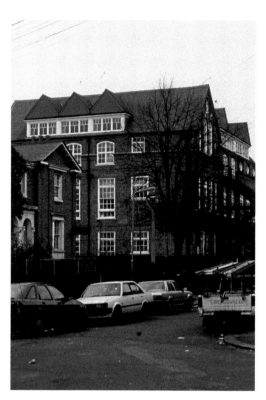

## Clapham Manor School

This local board school was built by the School Board for London in the 1880s, on a site occupied by a school since at least the 1840s. The building has been upgraded at various times and in 2009 award-winning architects, de Rijk Marsh Morgan (dRMM), added an extension joined to the original Victorian building by a triple-height glass atrium forming a new entrance to the school. The façade of the new extension is formed of glass panels, some of which are brightly coloured, and some upholstered on the inside to allow the display of children's work. It can just be seen in the lower picture behind the original building.

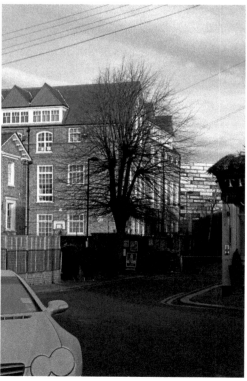

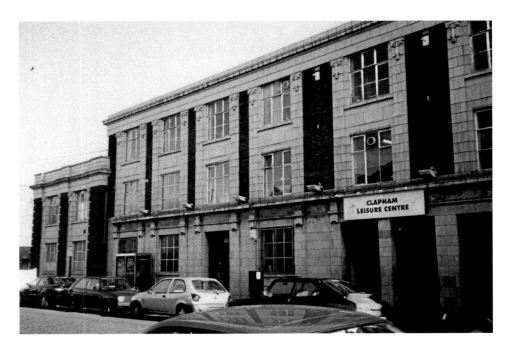

### Clapham Leisure Centre

Clapham Baths, opened in 1932 by Wandsworth Council (Clapham was then in the borough of Wandsworth) had the latest filtration system, several club rooms for meetings and the swimming pool could be covered with a sprung maple floor for use as a dance hall during the winter. The 1930s 'slipper baths', which provided public washing facilities, were converted in the 1990s into a gym. The building was replaced in 2012 by Clapham Leisure Centre, which has two pools, a fitness centre, badminton courts and sports hall, and offers a wide variety of classes and courses.

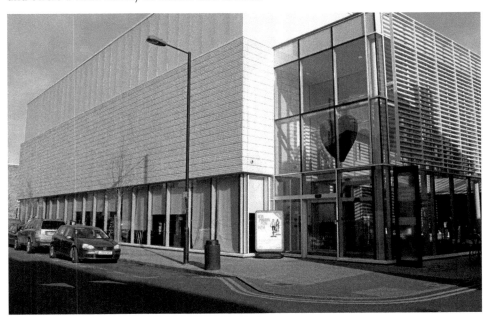

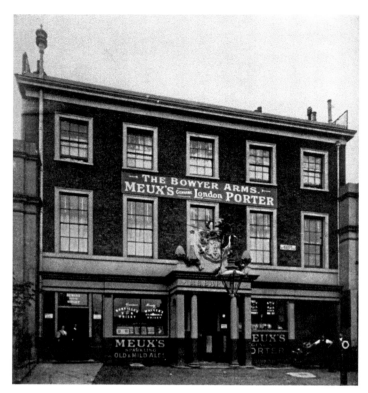

**The Bowyer Arms**
Although the important nineteenth-century builder, Thomas Cubitt, was responsible for the layout and development of Clapham Manor Street, The Bowyer Arms and the two houses flanking it was one of only two blocks he built himself in the street (*c.* 1850). The original name celebrates the Lord of the Manor, Major Atkins Bowyer. In 1996 the pub was taken over by the Workers Beer Company and renamed Bread and Roses, a political slogan and title of a song associated with a strike of female textile workers in Massachusetts in 1912.

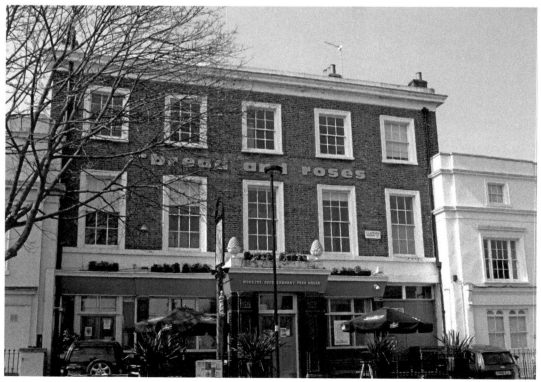

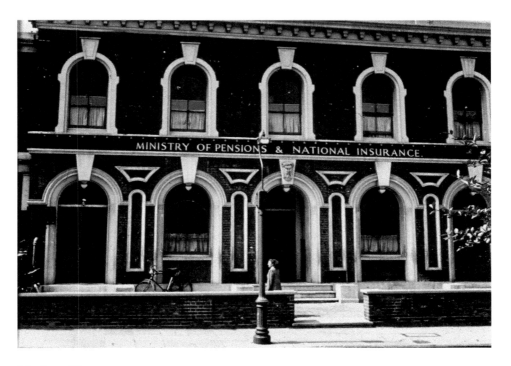

### Clapham Dispensary

This, the second Thomas Cubitt development in Clapham Manor Street, was designed free of charge by the local architect J. T. Knowles senior (1806–84), and built in 1850–54 by public subscription on land given for a Charitable Dispensary by the ground landlord, Major Atkins Bowyer. Thomas Cubitt himself donated 25 guineas (£26.25) each year to the dispensary. Seen above in the 1950s, the building has been put to several different uses since, including a Green Badge Taxi Drivers' School, and it is now the London Russian Ballet School.

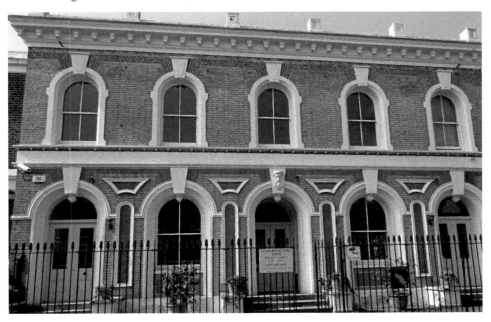

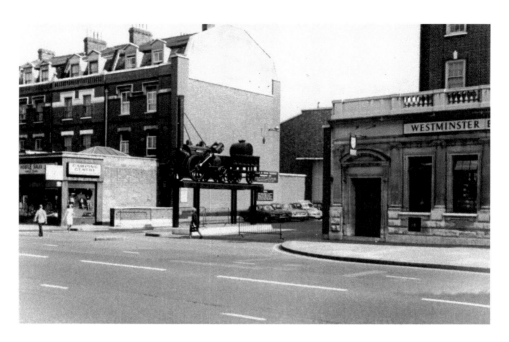

## Museum of British Transport

In 1885 a horse-tram depot with stables opened on this site, with a narrow entrance between existing shops. This was rebuilt in 1904 to accommodate the new electric tramcars. The buildings were completely destroyed by bombing in the Second World War, and rebuilt in 1950 as a bus garage. This closed in 1958, and the Museum of British Transport opened two years later. The entrance, with its replica of Stephenson's Rocket, is shown above. In 1973 the museum closed, the collection was divided between York and Covent Garden and this became a bus garage again. It was later a go-kart track, and disused until in 1996 Sainsbury's acquired this site and three adjoining properties to build their new store.

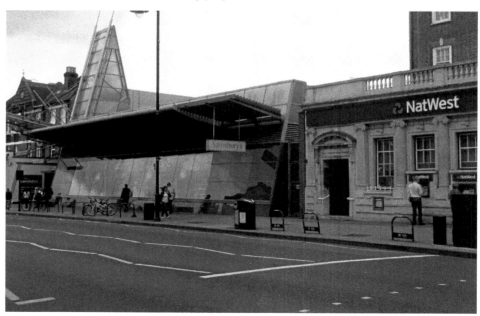

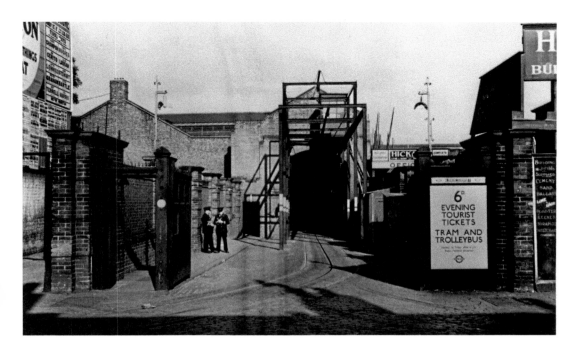

### Exit from Tram Depot

This picture, dating from the 1930s, shows the exit in Clapham Park Road from Clapham electric tramcar depot, the entrance to which was in Clapham High Street. Originally a horse tram depot, it was rebuilt in 1904 for electric trams. The depot was destroyed in the Second World War and, as part of the site described on the opposite page, it went through the same various transitions until it was remodelled in the 1990s as the entrance to Sainsbury's car park and rear entrance to the store. Originally an outdoor parking space this was later covered in and a second level of parking added.

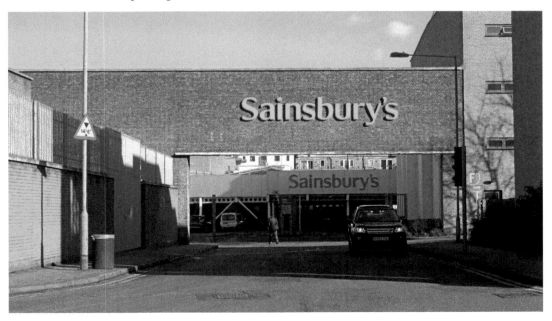

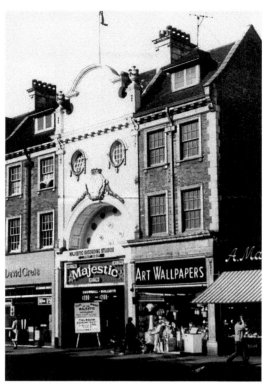

## Majestic Cinema

The Majestic Cinema, opened in 1914, was one of four cinemas in Clapham High Street by the 1920s. The cinema seated 3,000 and in the days of silent films was famous for its symphony orchestra, which was later replaced by a theatre organ. Part of the building was converted to recording studios, where Adam Faith and David Bowie are said to have recorded albums. The Majestic eventually became a Gaumont cinema and then a bingo hall, before opening as Cinatra's club in 1985. After various changes of name it is now Infernos.

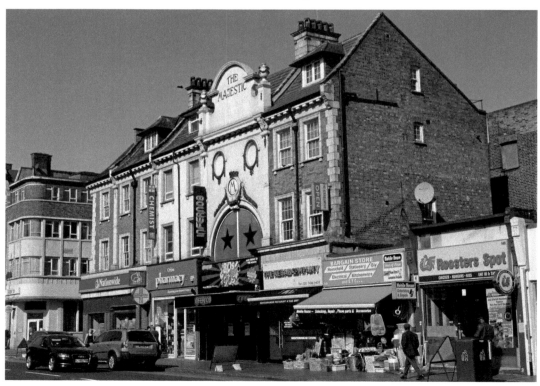

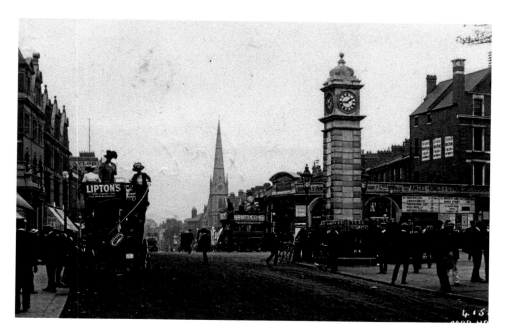

## The Clock Tower

Erected in 1906 the Clock Tower was the gift of Alexander Glegg, Mayor of Wandsworth, the borough in which Clapham then was located. A plaque at the base marks his gift. In the upper picture, the entrance to the underground station is shown in its original position prior to the extension of the line and removal of the entrance to its present location. In the distance is the spire of the Methodist Church which was destroyed by bombing in the Second World War. This was one of the three spires, once known as the Three Sisters of Clapham. The Congregational Church in Grafton Square was also lost in the war and the only surviving one is St Mary's Church in Clapham Park Road.

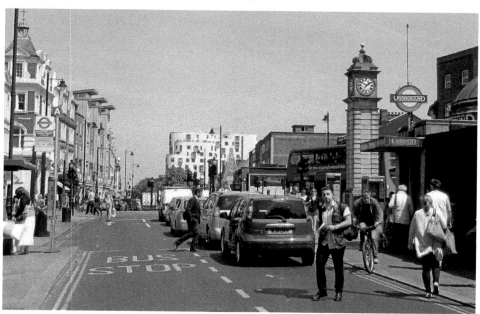

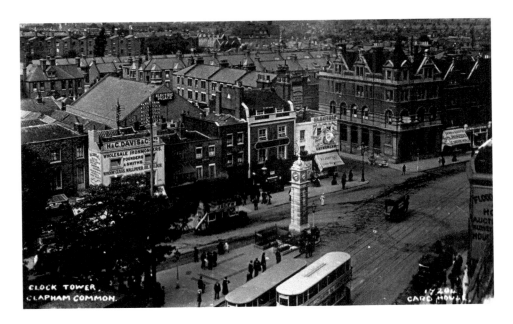

## Clapham Cross from Above

This brings us back to the first view in the book, but seen here from the spire of St Mary's Church. The top picture was taken about fifteen years after the view on page 5, by which time there was already a cinema in Venn Street, though not yet with the elaborate façade. The cinema building can be seen behind, in much the same position as the present Clapham Picture House. The builders' merchant H. & C. Davis, with prolific advertising painted on the façade, extended back to Bromells Road. This is now the green-painted Byron, which adjoins the Stane St Syndicate bar, formerly The Plough, seen above before the addition of its Tudor frontage.

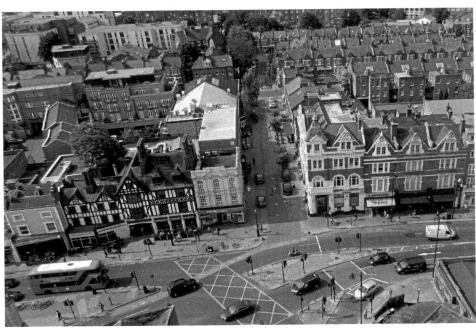

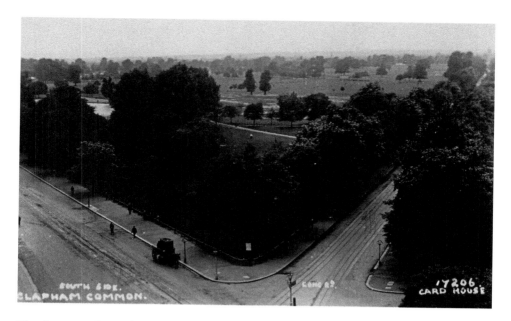

### The Common from the Spire of St Mary's Church

Throughout the time we were preparing this book the spire of St Mary's Church, Clapham Park Road, was covered in scaffolding and as the only spire and the tallest point in the centre of Clapham it seemed to insinuate itself into a high proportion of our photographs. So it was particularly pleasing that we finally had the opportunity, in a visit organised by the Clapham Society and the contractors, to climb to the top of the spire to inspect the works and take some stunning high-level pictures. This one shows the Common and road layout changed little in over 100 years. The dome in the centre foreground is on The Alexandra.

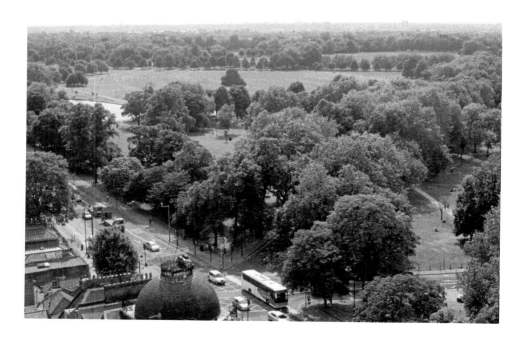

# Acknowledgements

This book is the result of the work of many members of the Clapham Society over many years, and in particular of the present Local History Sub-committee.

Most of the old photographs belong to the society: the early postcards come from collections given to the society, whilst later photographs have been taken by members to illustrate talks, or in relation to planning and conservation issues. We are particularly grateful to Clapham Society member Michael Surridge for filling several gaps from his extensive personal postcard collection. Other pictures have been very kindly provided by Jason Damon (p. 74), Ted Hayward (pps. 26 & 27), Susan Hill (p. 77), Michael Squire (p. 55), Lambeth Archives (pps. 16 & 90), ©TfL from the London Transport Museum collection (pps. 20 & 21) and Timothy Walker (p. 44). All the new photographs, except p. 77 (Nick Yeates) have been taken by Claire Fry within the last six months.

For the text, which reflects the situation in August 2015, we are much indebted to Clapham's local historians. Several important books on the history of Clapham are now out of print, but available to consult at Lambeth Archives. *Discovering Clapham* and *Clapham in the Twentieth Century* (both by Peter Jefferson Smith and Alyson Wilson) are in print and available at local bookshops and on the Clapham Society website.

Peter Jefferson Smith and Derrick Johnson have given invaluable help in selecting the pictures, reading the text, correcting errors and suggesting improvements for which the authors are extremely grateful.

Full details of the Clapham Society are available at www. claphamsociety.com.